IMAGES
*of America*

# RAILROAD DEPOTS OF NORTHWEST OHIO

D1599549

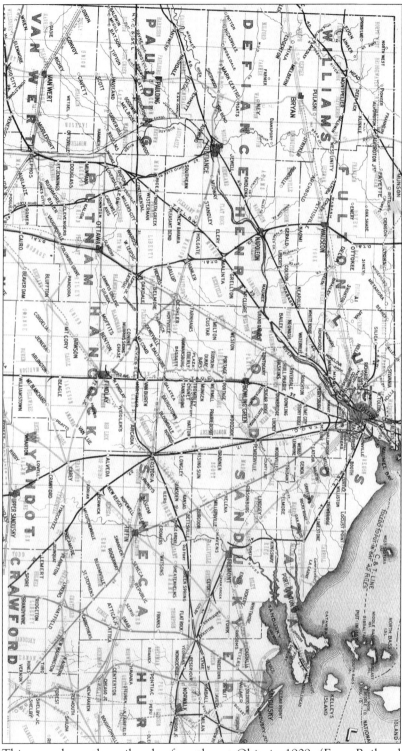

This map shows the railroads of northwest Ohio in 1909. (From Railroad Commission of Ohio State Map.)

IMAGES
*of America*

# RAILROAD DEPOTS OF NORTHWEST OHIO

Mark J. Camp

ARCADIA

Published by Arcadia Publishing
Charleston SC, Chicago IL, Portsmouth NH, San Francisco CA

Printed in Great Britain

Library of Congress Catalog Card Number: 2005922323

For all general information contact Arcadia Publishing at:
Telephone 843-853-2070
Fax 843-853-0044
E-mail sales@arcadiapublishing.com
For customer service and orders:
Toll-Free 1-888-313-2665

Visit us on the internet at http://www.arcadiapublishing.com

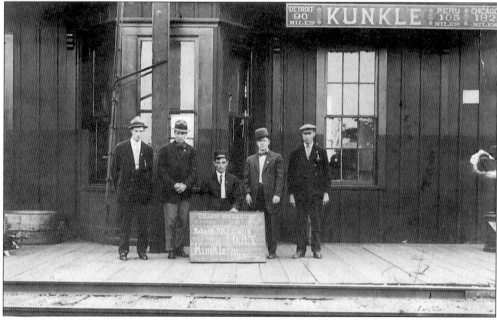

Operators of many Ohio depots were members of the Order of Railroad Telegraphers (ORT). Here, the staff of the Wabash depot at Kunkle proudly announce their membership on the depot's plank platform around 1907. Behind them is the bay window and lower stand of the order board. (Mark J. Camp collection.)

# CONTENTS

# ACKNOWLEDGMENTS

Although this work is far from comprehensive, it would be much less so if not for the help of the following individuals and organizations: Howard Ameling of Lakeland, Florida, Charles Bates and the late John Keller of the Allen County (Ohio) Historical Society of Lima, the late Gustave Erhardt of Toledo, Dale and Dave Fahle of Pemberville, the late Charles Garvin of Maumee, Kirk Hise of Genoa, Carl Hopfinger of Port Clinton, Bob Lorenz of Fremont, Oberlin College Library, The Railroad Station Historical Society, Toledo-Lucas County Public Library, The University of Toledo Carlson Library, and all the libraries and societies of northwest Ohio that maintain historical materials. Thanks also to Terry Fell of the University of Toledo for technical assistance.

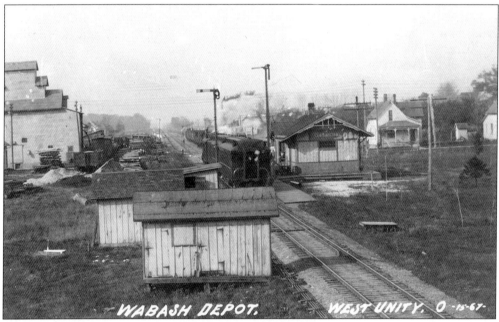

This early 1900 scene of the Wabash depot at West Unity shows many of the characteristics of a small town combination depot. The high semaphore signal in front of the depot is the order board. The two semaphores on the left side of the track are for the passing siding beyond the depot and the crossing of the Cincinnati Northern, West Unity's other railroad, behind the photographer. Pipes running along the track are interlocking conduits from the out-of-view interlocking tower, from which this picture was probably taken. A baggage cart rests on the plank platform. Sheds in the foreground are for a hand-car and tools. (Mark J. Camp collection.)

# INTRODUCTION

Northwest Ohio of the late 1800s rapidly became a crossroads of railroads intent on reaching Chicago, Detroit, and major cities along the Mississippi and Ohio Rivers. Here east–west lines of the Baltimore and Ohio; Lake Erie and Western; Lake Shore and Michigan Southern; New York, Chicago and St. Louis; Toledo, St. Louis and Western; Wabash; and Wheeling and Lake Erie cross north–south routes of the Baltimore and Ohio; Cincinnati, Hamilton and Dayton; Cincinnati Northern; Cleveland, Chicago, Cincinnati and St. Louis; Detroit, Toledo and Ironton; Hocking Valley; Pennsylvania; and Toledo and Ohio Central. The history of these lines extends back to the mid- to late 1800s.

To serve business, industry, and the traveling public, railroads established stations at regular intervals or selected sites along their lines. A station was a designated point along the line where trains might stop to conduct freight and passenger business, check for telegraphed orders, or to fuel and service locomotives. Most stations required some type of shelter from the elements—thus, the depot was born. The first depots often amounted to nothing more than a platform shelter, three-sided lean-to, or boxcar. Often a town grew up around the depot, eventually necessitating a larger depot. Some early depots served not only passengers, baggage, and freight, but also contained space for grain storage. A few offered living space for the agent's family, but this was not as common in Ohio as farther west, because most stations lay within already established communities with available housing.

Depots became symbols of respective railroads—a marketing tool. Lines employed an engineering staff to design functional structures. Many had bay windows affording the operator an unobstructed view up and down the track. An order board, either attached to the trackside of the depot or on a separate pole on the passenger platform, served as a signal to the crews on passing trains. The agent could adjust the position of the semaphore blades and/or lights on this feature to convey orders to the engineer and his crew. Standard plans developed for depots, towers, and accessory buildings based on the importance and size of a community. Smaller towns received combination depots that typically had a waiting room and freight room separated by an agent's office where tickets were sold and freight and baggage claims made. These buildings could be lengthened or shortened as need required. Separate passenger depots arose where passenger traffic was brisk. Across or down the track, a separate freight depot supplemented the passenger facilities. Towns served by two or more railroad lines and major cities may have had a union depot where railroads shared the passenger amenities. Outside architects might be commissioned to design such buildings. Where freight business was heavy, separate freight houses might handle inbound and outbound materials. Larger freight stations usually had offices at one end—the head house—and a long freight shed attached at the other.

Other structures associated with depots include interlocking, switch, and signal towers. In the late 1800s, these were placed at regular intervals along railroads. Towers facilitated traffic control, manned by operators who reported train positions by telegraph, provided orders to train crews, watched for hotboxes and other potential mechanical problems, and made certain switches and signals were properly set to avoid derailments and collisions, a process referred to as interlocking. In later years, towers were mainly needed at diamonds, where different lines crossed, and at passing sidings on single track stretches. Watchtowers stood at major road crossings to control gates or provide shelter for a crossing watchman. They were often elevated to provide the watchman better visibility.

Steam and diesel locomotive servicing facilities such as water, sand, and coaling towers, roundhouses, and shops were located near some depots, but usually the railroad found them to be more efficient in the midst of yards or in locations far removed from passenger handling structures.

Other structures often found nearby were lunchrooms, hotels, and, at major terminals, the Railroad YMCA. Before the advent of the dining car, restaurants, or "beaneries," designed to serve passengers and railroad crews, often were part of the depot scene at selected points. Examples existed at Bellevue, Montpelier, Walbridge, and Willard into the mid-1900s. Railroad hotels were often located at junctions even in the smallest communities. Boarding houses offered rooms to railroad men. At major terminals like Bellevue, Montpelier, Toledo, and Walbridge, Railroad Ys offered clean and safe places to stay.

Following are illustrations of a sampling of these structures, mainly passenger and combination depots, across 14 northwest Ohio counties. The boundaries of the included area are the Ohio–Michigan and Ohio–Indiana state lines and Lake Erie to the north and west; the NYC&StL (now NS) and B&O (now CSX) mainlines to the south from Seneca to Paulding Counties; and the central part of Erie and Huron Counties to the east. Future volumes will continue the study into neighboring parts of the Buckeye state. As is the case with many a historical compilation, completeness is hard to obtain. If it wasn't for the pioneer photographers who recorded the landscape for postcards, the historical record would be much less complete. It's unfortunate that many of their names have been lost to history so it is impossible to give them due credit. Readers willing to share photographs and information of depots are encouraged to contact the author through the Railroad Station Historical Society website www.rrshs.org (an updated list of what's needed is accessible through the Ohio page of extant structures) or the University of Toledo website www.utoledo.edu/eeescience/Camp/.

Historical information for this book came from *Reports of the Ohio Railway Commission*; *Annual Reports of the Public Utilities Commission of Ohio*; *Poors Manuals*; *Railroad Gazette*; *Railway Age* and other trade journals; various newspapers of northwest Ohio; numerous centennial, sesquicentennial, and bicentennial compilations and histories of northwest Ohio communities; and firsthand interviews conducted over the last 40 years.

# One

# BALTIMORE AND OHIO LINES

In 1837, a primitive rail line, then known as the Mansfield and Sandusky City Railroad, was building a line between Sandusky and Monroeville. Horses were the initial power source, on into the mid-1840s. By 1855, the line had reached Newark and was known as the Sandusky, Mansfield and Newark. From 1852 to 1863, a branch operated from Prout (Station) to Huron. By 1869, the SM&N was under control of the Baltimore and Ohio Railroad and served as a future connection between B&O's Central Ohio line and a proposed line to Chicago and Pittsburgh in northern Ohio.

In August 1859, the first Dayton and Michigan Railroad passenger train traversed a route from Dayton to Toledo. Four years later the route came under operation of the Cincinnati, Hamilton and Dayton Railroad Company. The CH&D also took over the Bowling Green Railroad, Cincinnati Fort Wayne and Findlay (to be covered in a later volume), and the McComb, Deshler and Toledo Railroad in northwest Ohio. The Bowling Green Railroad opened in 1875 between Tontogany and Bowling Green and became part of the CH&D in 1886. The MD&T opened in December 1880 as a branch of the Dayton and Michigan from Deshler to McComb. This line was extended to Findlay in 1889 as the Columbus, Findlay and Norwalk Railroad. In 1890, the CH&D opened the North Baltimore extension between Bowling Green and North Baltimore, known corporately as the Toledo, Findlay and Springfield Railway. In 1917, the CH&D disappeared into the Baltimore and Ohio Railroad.

In 1872, the Baltimore, Pittsburgh and Chicago Railway was projected from a point west of Pittsburgh, Pennsylvania, on the Ohio line westward to the Indiana line near Hicksville and on to Chicago. A change in the charter made the eastern terminus a point on the Sandusky, Mansfield and Newark Railroad to be called Chicago Junction. The line opened to North Baltimore by October 1873, to Deshler by November 1873, to Defiance by June 1874, and to Hicksville by November 1874. The year 1878 brought reorganization and a new name—the Baltimore and Ohio and Chicago Railroad. The year 1891 marked the completion of the extension to Pittsburgh, by way of Akron and Youngstown; a line chartered as the Akron and Chicago Junction Railroad.

By the early 1900s, replacement B&O depots were built to a series of standard plans across the entire system. Unfortunately, examples of the smaller town structures no longer exist in the area; only larger brick depots remain at Defiance, Deshler, and Fostoria and a larger frame building at North Baltimore. CH&D depots from Bowling Green, Findlay, Leipsic, Ottawa, and Weston also survive.

# Baltimore and Ohio Depots

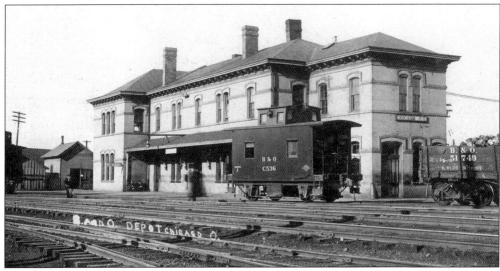

This large passenger depot opened in September 1875 after the B&O opened its line across northwest Ohio to Chicago. A roundhouse and shops joined the depot in 1876, and Chicago Junction became a major engine terminal. In 1917, Chicago Junction became Willard after B&O President Daniel Willard. The depot had a restaurant, offices, and sleeping rooms. Passenger service ended in 1969, and the depot was demolished in 1976. The railroad yard is still there, used by CSX, but a few prefab buildings have replaced the roundhouse, coaling station, water tanks, and various shop buildings. Architectural parts from the depot now form walls of the Willard Railroad Museum on South Main Street. (Mark J. Camp collection.)

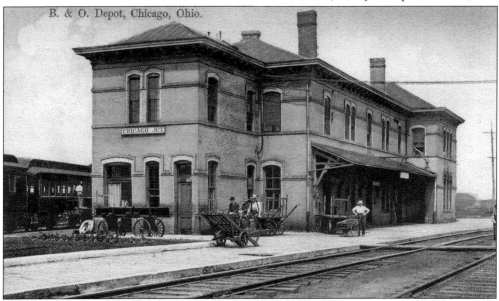

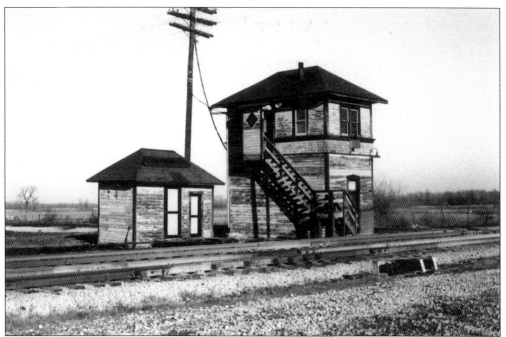

West of Willard, the B&O crosses the PRR, just north of Attica. Originally called Attica Station, it became Attica Junction to the railroads and Siam to the postal service. All that remained by 1964 was an interlocking tower of typical B&O design; even this was gone by the early 1970s. (Charles Garvin photograph.)

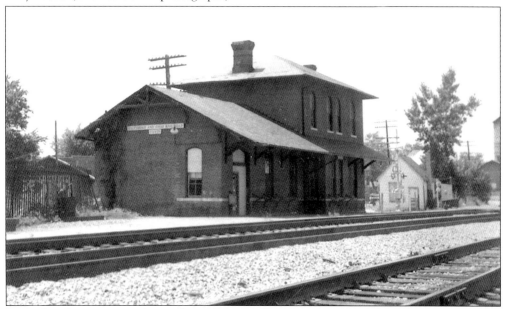

Five other depots were within walking distance of the B&O passenger depot on North Monroe Street in Tiffin until the mid-1960s. The brick depot dates to the opening of the B&O line from Willard to Chicago in 1874. The importance of Tiffin as a railroad center demanded separate passenger and freight facilities. A one-story brick freight house (still standing) was west of this building. Unfortunately, the passenger depot shown here in 1972 was demolished in 2000.

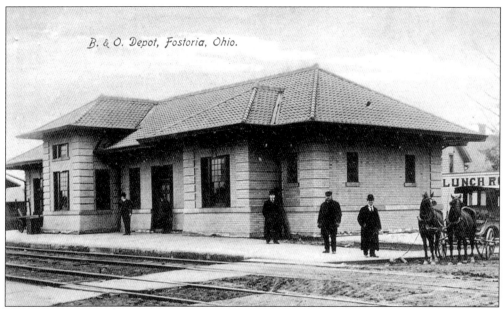

B. & O. Depot, Fostoria, Ohio.

Fostoria's B&O passenger depot opened in March 1907 and closed to passengers in 1971. This 1907 view shows a hotel hack awaiting the arrival of a passenger train back when the depot saw the arrival of several trains daily. Amtrak added a stop in Fostoria from 1990–1995, but didn't use the depot. In 1997, Amtrak returned to town, this time using a renovated waiting room in the depot until service was discontinued in 2005. (Mark J. Camp collection.)

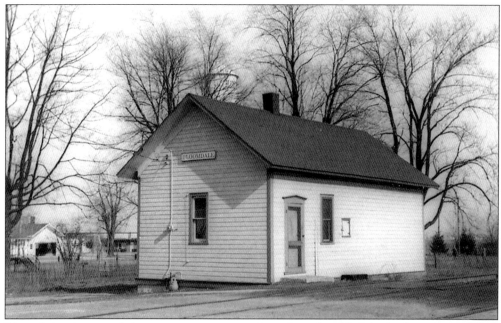

Bloomdale was one of the many communities formed as the B&O built through northwest Ohio. A depot was built here in 1874; eventually, a water tank was constructed across the tracks. By 1971, the Bloomdale combination depot had been modified by the B&O maintenance forces into a rather plain-looking structure. Only the trim around the door suggests that it was once a more attractive depot. The building no longer exists.

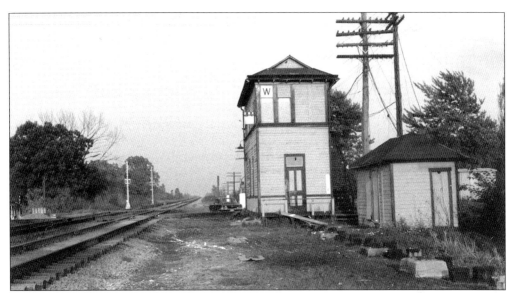

Galatea was the crossing of the B&O and Toledo and Ohio Central, guarded by this interlocking tower until the late 1960s. In the 1880s, L-shaped passenger and freight depots were built by a predecessor to the T&OC, but these disappeared in the mid-1900s. On the second floor of the tower were levers that were shifted by the operator to set switches on wyes to the T&OC and crossovers and controls for the block signals. The letter "W" was the code name of the tower on the B&O line. (1965 Charles Garvin photograph.)

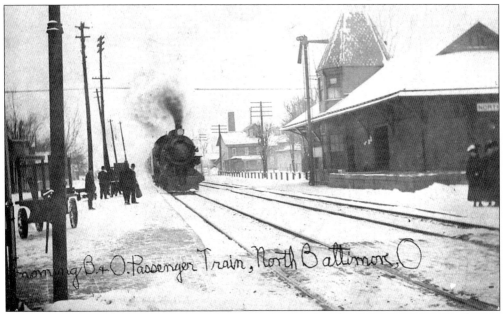

The train to Chicago arrives on a wintry afternoon in North Baltimore sometime around 1910. The depot probably dates to the 1880s and exhibits a second-floor octagonal tower, which allowed the operator an unobstructed view up and down the line. Looks like there wasn't enough time to clear the platforms, but the baggage carts await the loading and unloading soon to happen. Before construction of the depot, tickets were sold in the B.L. Peters' Store. The depot remains, but the tower was removed long ago. (Mossholder photograph, Mark J. Camp collection.)

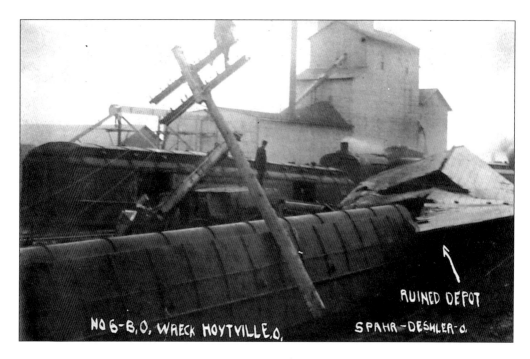

NO 6-B.O. WRECK HOYTVILLE.O.  SPAHR-DESHLER-O.

RUINED DEPOT

A B&O passenger train derailed at Hoytville in 1913, sending a coach into the frame depot. The B&O replaced the demolished structure with a depot built to standard B&O plans, which served Hoytville until reportedly burning down in the late 1960s. Alternatively, although not confirmed, this second depot may have been moved to Hoytville from another location. (Above photograph from the Mark J. Camp collection; below, 1967 Charles Garvin photograph.)

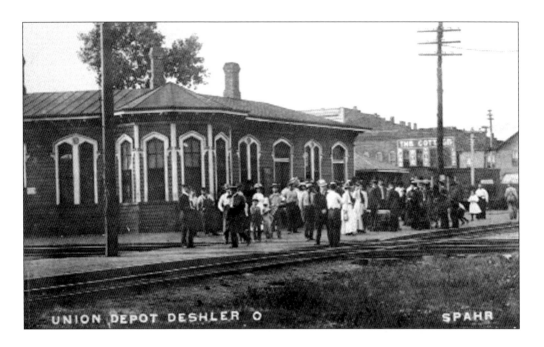

Deshler developed around the crossing of the B&O and CH&D. The B&O built a union depot, shown above, in 1873–1874. In 1915, the current brick depot opened. Deshler became "the crossroads of the B&O," once serving 16 daily passenger trains, with two nearby restaurants open 24 hours to accommodate travelers. By 1960, six passenger trains used the depot daily. The year 1965 marked the closing of the Railway Express Agency facility. Diagonally across the tracks is a 1931 brick, interlocking tower, which closed in 1986. (Mark J. Camp collection.)

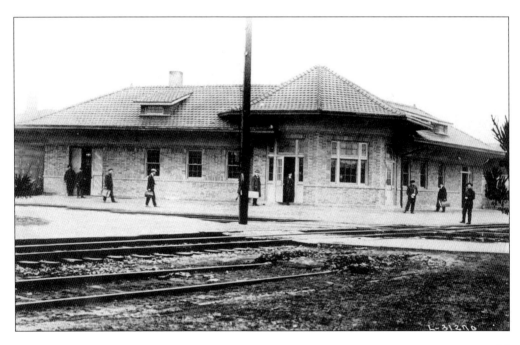

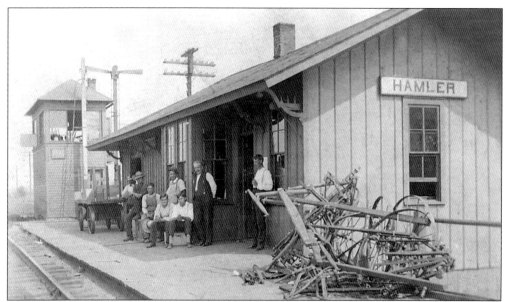

This *c.* 1908 view shows the original B&O combination depot, dating to 1874, at Hamler where the B&O crosses the DT&I. The staff and some local boys, maybe apprentices, pose for the photographer. The plank platform appears to extend along the DT&I between the depot and tower, making this a union depot. The rectangular frame interlocking tower is of Detroit and Lima Northern origin, probably built in 1898. A pile of wagon and cart parts lies in the foreground. In 1912, a brick B&O interlocking tower was built at this diamond. It closed in 1986. (Mark J. Camp collection.)

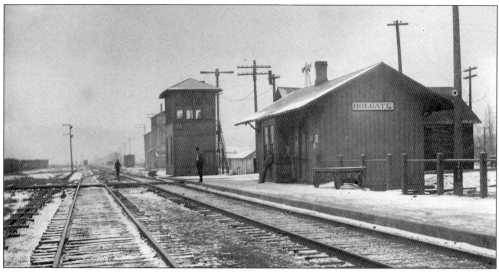

The scene is repeated at Holgate, the crossing of the TStL&W or Cloverleaf. Note that the depots at Holgate and Hamler are the same, but have a reversal of the waiting and freight rooms. The interlocking tower, although similar to Hamler, is of B&O design. Hidden behind the B&O depot is the separate depot of the TStL&W. Around 1912, the B&O built a brick tower, identical to the one at Hamler, at the Holgate diamond. This tower was torn down in August 1966. A B&O depot, of later design, remains at Holgate, although the Cloverleaf tracks are gone. (Mark J. Camp collection.)

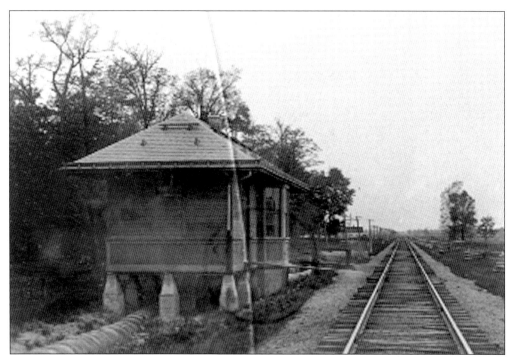

The B&O built new facilities at Standley around 1910, including this standard-plan combination depot and an interlocking tower of the same design as Hamler and Holgate. Compare the depot design to Hicksville, Hoytville, and Mark Center. The structures were gone by the late 1960s. (Mark J. Camp collection.)

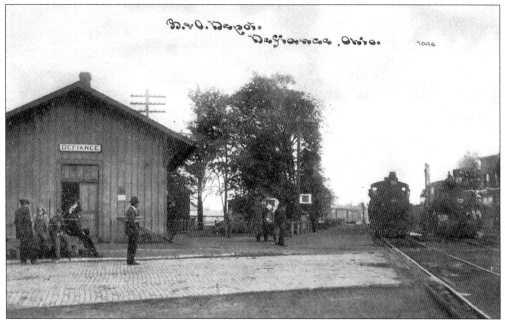

This 1875 depot served as a union depot at Defiance for the B&O and Wabash railroads. In 1917, the B&O moved to a new facility. Nearby was an 1881 ice house and 1882 express building. The depot was removed in 1919. (Mark J. Camp collection.)

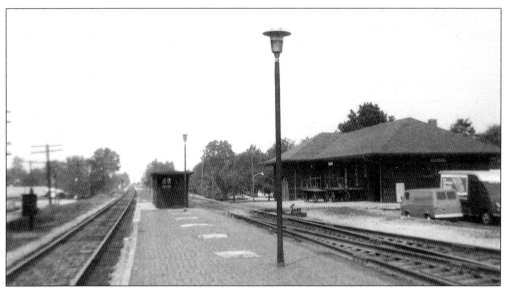

In 1967, the B&O still stopped for passengers at this two-story brick depot built during a 1916 track elevation project. The opening date, November 19, 1917, was a day of celebration. A brick freight house, also dating to 1916, sat east of the passenger building until 1975. The platforms and shelters are gone, but the passenger depot remains.

The B&O crosses the Cincinnati Northern at Sherwood. The 1875 B&O depot here was modified to serve as a union depot, with the addition of a multi-sided corner bay window and capped by a tetrahedral roof, when the CN opened in 1886. A frame interlocking tower sat across from the depot. The three-story tower, dating to 1912, seen in this 1967 view sits on the site of the old union depot. A small frame CN freight house was also present until the late 1960s. The agency closed in 1965. The tower was torn down in 1979. (Charles Garvin photograph.)

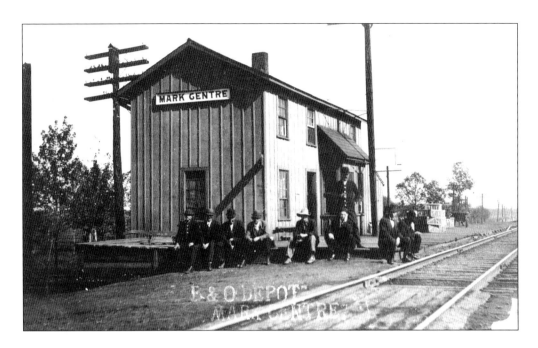

In 1911, Mark Center (note earlier spelling) had a two-story depot, probably dating back to the 1870s. When the B&O established this station, housing was not available for the agent so the railroad added a second floor for a living space. It is likely this depot burned down or was replaced sometime soon after this photograph was made, for below is a view, also from an early 1900 postcard, of the replacement depot. Mark Center was an important shipping point for local farms—note the milk cans. Boys also found the depot to be an exciting "hangout." Reportedly, the depot became a house after its railroad use ended. (Mark J. Camp collection.)

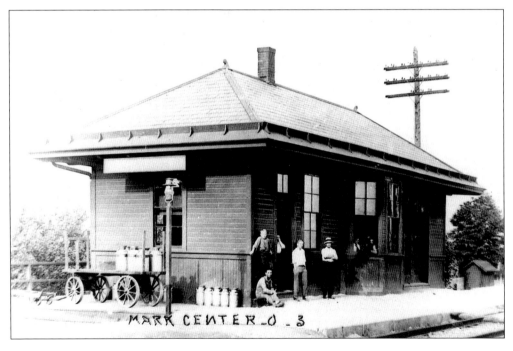

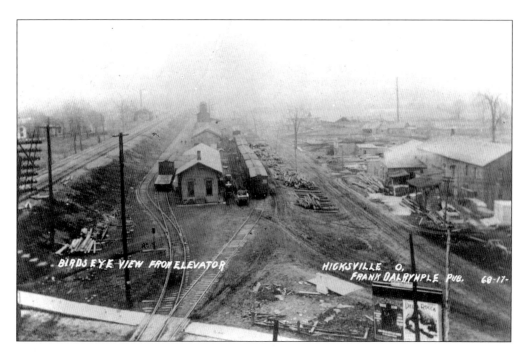

Hicksville incorporated after the B&O built through the community in 1874. The 1874 B&O depot is seen above after the track elevation of the early 1900s. At this time, it became a freight depot. The depot was still there in the late 1960s, but has since been torn down. Below is the newer Hicksville depot, built to an early 1900 B&O standard plan and located on the elevated portion of the line. Reportedly, the depot came from another site and was transported to Hicksville on flat cars. It sat vacant and vandalized by 1965. (Mark J. Camp collection.)

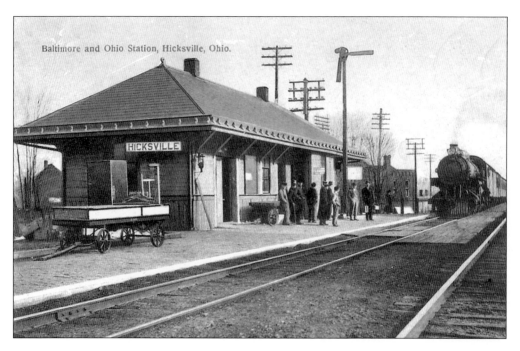

The Sandusky, Mansfield and Newark Railroad brought another major line to Sandusky when it opened in 1853. Many years later, the northern terminus of this B&O line was graced by this attractive brick, stone, and tile passenger depot. The B&O discontinued passenger service between Sandusky and Willard in 1938. By the 1960s, the depot served as a storage facility, and although on the National Register of Historic Places, it was demolished in the 1970s. (1965 Charles Garvin photograph.)

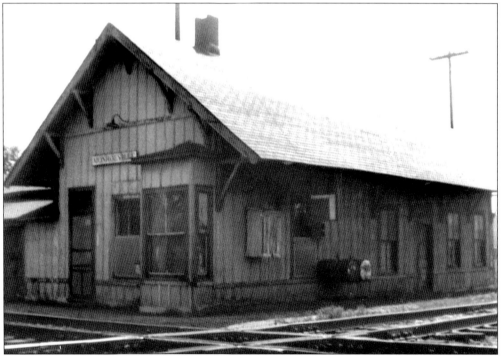

The B&O crossed the W&LE at Monroeville where a combination B&O–W&LE depot sat in later years. The SM&N predated the W&LE by 29 years and certainly had an earlier frame depot here. This picture, taken in 1966, shows the standard plan W&LE depot built at the diamond. The B&O line runs by the bay window end of the depot; an addition is also along the B&O tracks. The depot was moved to near Milan as part of a camp; it now serves the Erie County Metro Parks as a lodge / meeting hall.

# Cincinnati, Hamilton and Dayton Depots

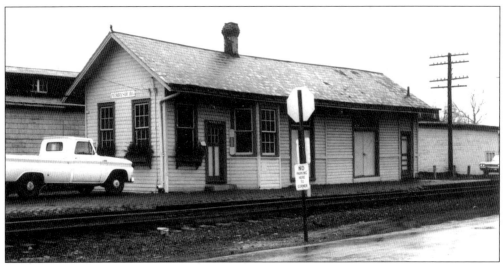

Just off Louisiana Avenue in downtown Perrysburg, the CH&D, later B&O, maintained an agency in this depot from 1896 to 1969. The agent in the 1960s took pride in this facility, adding flower boxes on the former passenger end. The passenger end of the depot was relocated a short distance to become part of a country club in 1971. (Charles Garvin photograph.)

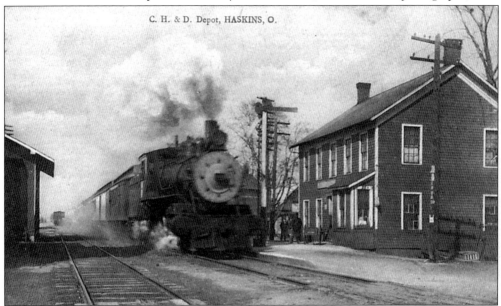

Two-story small town depots, such as this one in Haskins, were not common in Ohio, for many communities preceded the railroads, and local housing was available for the agent. CH&D's 2:30 Flyer has just arrived. Across the track is a small freight house. This depot was gone by the mid-1900s, and only a sign announced the location. (Mark J. Camp collection.)

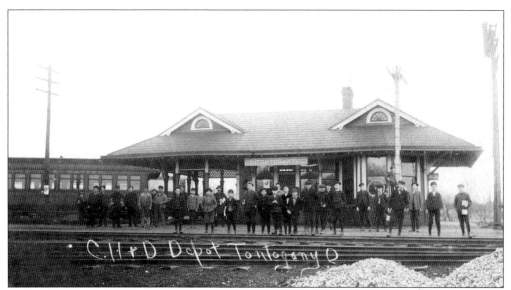

The CH&D passenger depot at Tontogany was probably built around 1875 with the opening of the Bowling Green Railroad. A unique feature was the open, covered waiting area. Business increased with the establishment of a state Normal School at Bowling Green in 1910. Here, the staff and local schoolboys pose for the postcard photographer around 1908. By the 1960s, the sheltered waiting area was gone, and the depot was sided with aluminum. Today, nothing remains. (Mark J. Camp collection.)

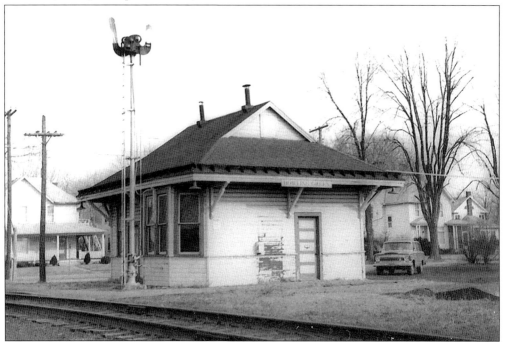

The 1894 CH&D passenger depot, once located on West Wooster Street, in Bowling Green saw its last passenger train in the 1960s and closed in 1976. Adjacent was a frame freight house, removed around 1965. The depot, shown here in 1971, was to be moved to BGSU, but ended up as part of the historical village in Dayton's Carillon Park beginning in 1978.

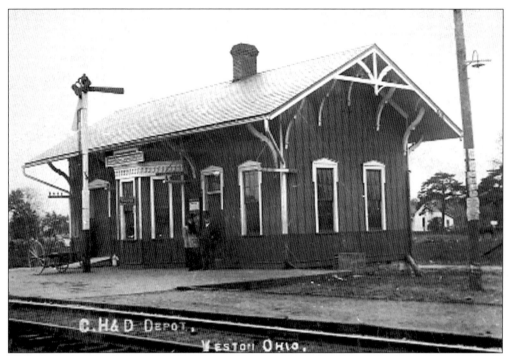

Weston was well served by this CH&D combination depot until its closure in 1966. The depot was moved to the Wood County fairgrounds in Bowling Green in the summer of 1970 and later restored. (Mark J. Camp collection.)

By the time this photograph was taken in 1964, the CH&D combination depot at Custar sat abandoned in a vacant lot. It didn't last much longer. (Charles Garvin photograph.)

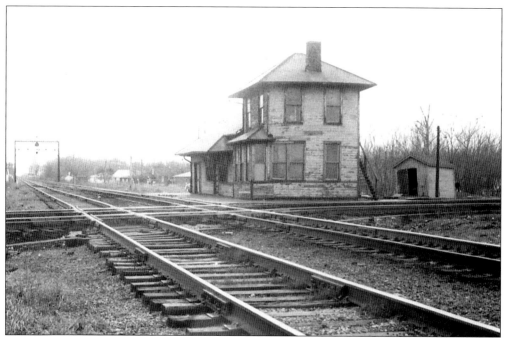

The 1882 NYC&StL crossing of the CH&D north of downtown Leipsic led to this new depot at Leipsic Junction. Once a busy site, the agency closed in 1969, and in November–December 1970, the junction depot was demolished. Only B&O's abandoned brick XN Tower, built in 1931 diagonally across from the depot, remains. Below is the downtown Leipsic depot of the CH&D around 1908. Note this combination depot lacks a bay window and lacks architectural embellishments with the exception of the shutters. This depot was relocated to Belmore and Center Streets and served a number of years as a church. (Above, 1965 Charles Garvin photograph; below photograph from the Mark J. Camp collection.)

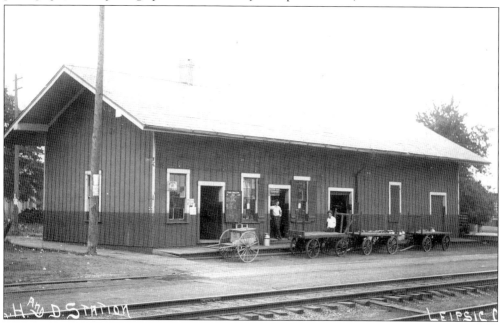

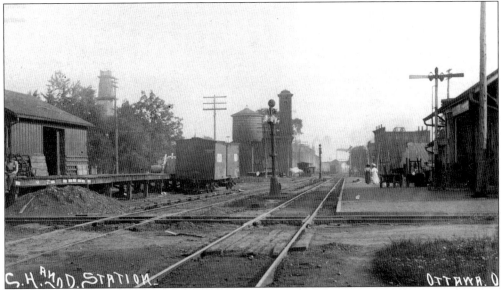

C.H. AND D. STATION.        OTTAWA, O.

The junction in Ottawa is within two blocks of downtown. The earlier CH&D passenger depot (above) is to the right at the diamond of the CH&D and Findlay, Fort Wayne and Western. Across the tracks is a small frame freight station. Between the tracks are penstocks that provided water, which was stored in the wooden tank down the track, to the locomotives. Ladies await the approaching Toledo-bound passenger train. By the early 1900s, the scene changed when a brick depot (below) was built on the site of the former frame depot. Although by 1965, the date of this photograph, the track of the FFW&W was gone; one could envision its presence due to the rectangular tower on the corner. B&O passenger service ended here in 1971. Today, the depot remains in use for railroad storage at Taft and Fourth Streets. (Mark J. Camp collection.)

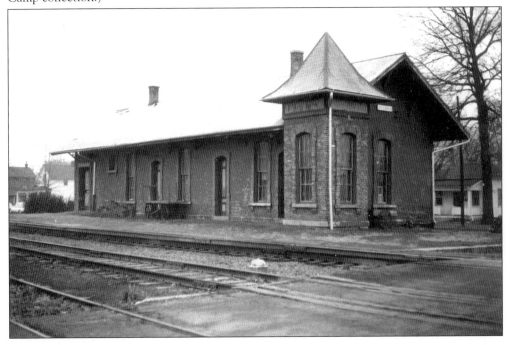

# Two
# NEW YORK
# CENTRAL LINES

The New York Central Railroad Company formed in 1853 through the consolidation of several New York railroads stretching between Albany and Buffalo. The system continued to grow in the late 1800s, adding lines across Ohio, including five that served northwest Ohio—the Big Four, Cincinnati Northern, Lake Shore and Michigan Southern, Michigan Central, and the Toledo and Ohio Central. The earliest railroads built through northwest Ohio—the Erie and Kalamazoo and the Mad River and Lake Erie—eventually became part of the system. The E&K opened from Toledo to Adrian, Michigan, in 1836; horses powered the pioneer line until 1837. The E&K became part of the Michigan Southern Railroad in 1849. The Northern Indiana Railroad opened a line directly west from Toledo in a straight path, or "air-line," to the Indiana line near Edgerton in 1852. In 1855, the Michigan Southern and Northern Indiana Railroads combined to become the Michigan Southern and Northern Indiana Railroad. The Lake Shore and Michigan Southern Railway formed from the consolidations of the Michigan Southern and Northern Indiana Railroad (Chicago to Toledo), Lake Shore Railway (Toledo to Erie, Pennsylvania), and Buffalo and Erie Railroad during the summer of 1869. The Lake Shore Railway was a consolidation of several former lines between Toledo and Ashtabula, including the Toledo Norwalk and Cleveland and Junction Railroads in northwest Ohio. The LS&MS also controlled the Detroit, Monroe and Toledo Railway, which reached Toledo from Michigan, and the Chicago and Canada Southern, which terminated at Fayette. The Chicago and Canada Southern was projected from Grosse Ile, Michigan, and Ontario across the northwest corner of Ohio, including Montpelier and Edon, and on to Chicago, but track never advanced beyond Fayette. The line opened in 1873 and fell under LS&MS control by 1879. A related line, the Toledo, Canada Southern and Detroit Railway, reached Toledo from Michigan, opening in 1873. The Michigan Central took over in 1883.

The year 1839 marked the opening of Mad River and Lake Erie track from Sandusky to Bellevue. The line reached Republic by 1839, Tiffin by 1841, and Dayton by spring of 1848. A short branch from Carey to Findlay was in operation by 1846. The line pulled up track from Sandusky to Tiffin by way of Bellevue and Republic in favor of a route through Clyde in the 1850s. The MR&LE went through a number of reorganizations, eventually becoming part of the Cleveland, Cincinnati, Chicago and St. Louis Railway, commonly known as the Big Four, in 1890. The Big Four also controlled the Cincinnati Northern beginning in 1902, a line built from Franklin to the Michigan border north of Alvordton by predecessors in the early 1880s. The first stretch opened in northwest Ohio from Paulding to Ohio City (then Enterprise) as part of the Cincinnati, Van Wert and Michigan Railroad in 1882. The line opened to the Michigan border around 1888.

The Ohio Central Railroad, originally projected by predecessors to connect the Hocking Valley coalfields and the Ohio River with Lake Erie in 1869, opened between Toledo and Middleport in 1882. After a merger with a West Virginia line, the Ohio Central became the Toledo and Ohio Central Railroad in 1885. The Toledo and Indianapolis Railway laid track

from Toledo to Findlay in 1883; reorganized and built to Dunkirk by 1889; and reorganized again as the Toledo, Columbus and Cincinnati, reaching Kenton in 1892. The T&OC took over the TC&C in 1893, completing the line to Columbus and a connection with the old Ohio Central mainline. The New York Central acquired the Lake Shore and Michigan Southern and Michigan Central in 1914, the T&OC in 1922, and the Big Four in 1930.

All these NYC lines inherited depot designs from their predecessors. Only a few depots were built after the NYC takeover, the most obvious being Central Union Terminal in Toledo. Although all the lines had standard depot plans, little repetition of design is evident in northwest Ohio, except along the LS&MS. LS&MS depots remain at Bellevue, Bryan, Delta, Elmore, Fremont, Monroeville, Norwalk, Oak Harbor, Pettisville, Rocky Ridge, Stryker, and Wauseon. The LS&MS also had a tendency to convert predecessor line depots to freight houses when building new passenger depots, for example. CCC&StL depots still stand at Green Springs and Tiffin, but all Cincinnati Northern structures are gone in northwest Ohio. T&OC depots from Hatton, Pemberville, Portage, Stony Ridge, and Sugar Ridge remain.

The NYC became the Penn Central in 1967 and Conrail in 1983. Former northwest Ohio NYC lines are now part of CSXT, NS, or newly organized shortlines.

# Cincinnati Northern Railroad Depots

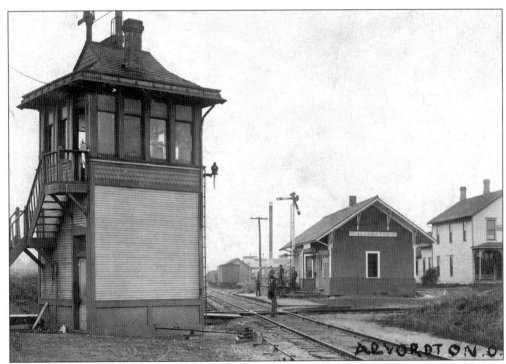

The Cincinnati Northern engineering office had a number of small town depot plans, few of which were noted for ornamental features. The depots were strictly utilitarian. In Alvordton, the combination depot is at the diamond with the Wabash. In the foreground is the Wabash's interlocking tower, and out of view is a separate Wabash depot. Behind the CN depot is a small railroad hotel. Although the tower survived until around 1983, both depots were gone by the late 1960s. (Mark J. Camp collection.)

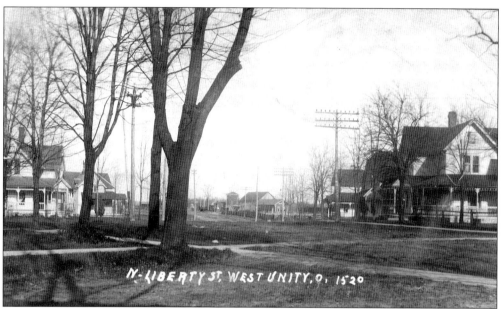

Another style of combination depot is seen at West Unity. Note the wooden water tank adjacent to the depot. In the distance is another crossing of a Wabash line. (Mark J. Camp collection.)

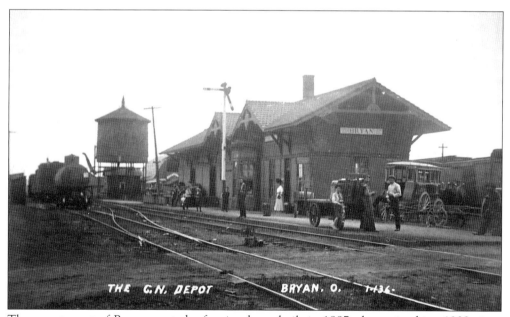

The county seat of Bryan sported a fancier depot built in 1887, shown in this *c.*1908 view. The adjacent water tank had an attached spout rather than separate penstocks. (Mark J. Camp collection.)

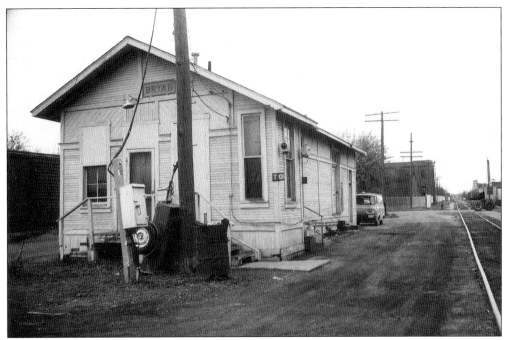

By the 1960s, the New York Central significantly modified the Bryan depot by removing the passenger end, chopping off the roof, and adding a small bay window. The depot was gone by the mid-1970s. (1969 Charles Garvin photograph.)

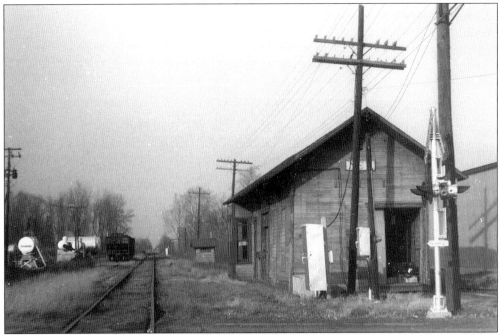

The railroad reached the edge of newly named Ney in 1888; it had been known as Georgetown. A boardwalk connected the business district with the depot for the convenience of passengers. The depot served as a storage building when this 1967 photograph was taken. It disappeared before 1970. (Charles Garvin photograph.)

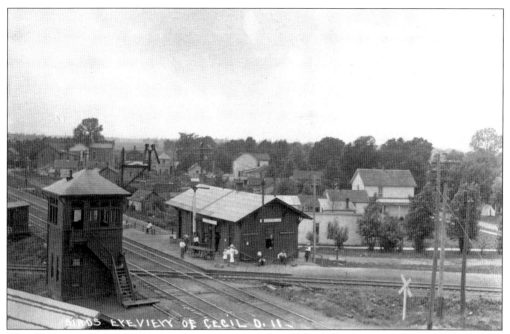

The CN crossed the double track main line of the Wabash Railroad at Cecil. The Wabash depot served as a union depot with the tower across the diamond providing protection at the crossing. (M.A. Sheets photograph, Mark J. Camp collection.)

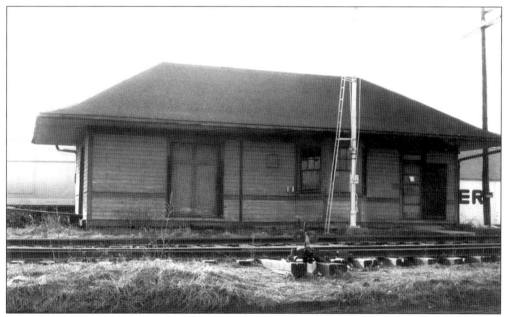

After fire destroyed the 1887 CN depot in Paulding, which had been built to similar plans as Bryan, the NYC built this standard-plan combination depot in 1940. It was removed in the late 1960s. (1967 Charles Garvin photograph.)

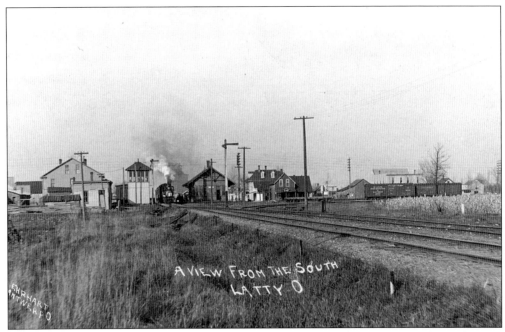

The NYC&StL crossed the CN at Latty and led to this union depot in 1882. This early 1900 view shows a CN accommodation taking on passengers. The interlocking tower, torn down around 1950, is of NYC&StL design. A railroad hotel is to the right. In 1964, below, only the foundation of the tower remains. Five years later, the depot was torn down for its lumber, and the agent moved into an outbuilding until the agency closed in 1974. Penn Central abandoned the CN in 1977. (Above photograph from the Mark J. Camp collection; below photograph by Charles Garvin.)

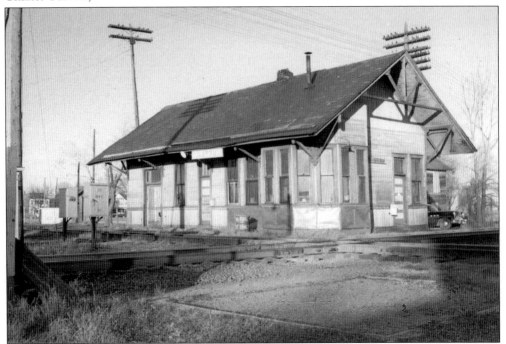

# Big Four Railroad Depots

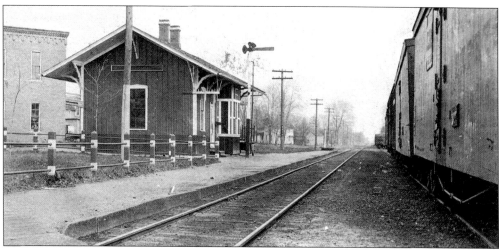

The Cleveland, Cincinnati, Chicago and St. Louis Railroad, or "Big Four," built this combination depot at Green Springs on the pioneer Mad River and Lake Erie route probably around 1890. This design was repeated at many stations across Ohio, Indiana, and Illinois. During its heyday, hacks whisked travelers from the depot to health resorts at the nearby odiferous mineral springs. Although unused for many years, the depot still stands along the old roadbed. (Mark J. Camp collection.)

The Big Four passenger depot in Tiffin was built by the Sandusky, Dayton and Cincinnati Railroad in 1862. The depot passed out of railroad use in 1959 and was used for storage in the 1960s. Restoration for office use began in 2000. Across the track in this 1967 view is the earlier Mad River and Lake Erie combination depot, converted to freight use in 1862. The freight depot also remains, but has been remodeled.

# Lake Shore and Michigan Southern Railroad Depots

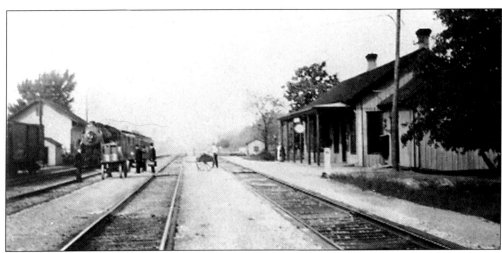

This frame passenger depot was built as the population of Edgerton grew in the late 1800s. The earlier depot became a freight house and can be seen across the tracks. The depots are gone, but the small park created around the passenger depot still exists. (Mark J. Camp collection.)

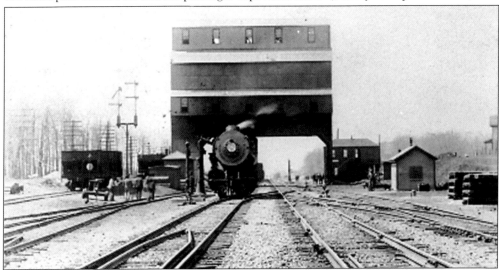

Mina, about half way between LS&MS engine terminals at Toledo and Elkhart, Indiana, received new facilities around 1905 when the railroad made track improvements. The large structure spanning the tracks is a coaling tower. Penstocks are to either side of this tower, fed by a large wooden tank off to the left. Just beyond the coaling tower, on the right, is a telegrapher's office. Abandoned steel tanks are the only reminders of this important stop today. (Mark J. Camp collection.)

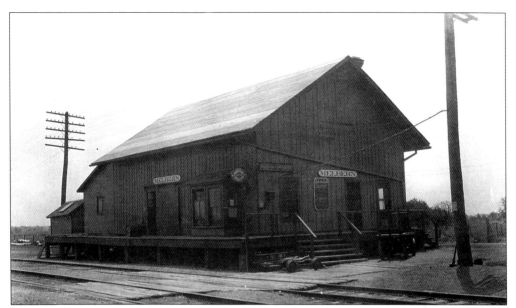

This 1918 view shows the LS&MS depot at Melbern. The passenger waiting rooms are on this end, the agent's office is trackside, the freight room is to the left, and grain storage is in the loft (note double doors under the eaves). The depot closed in 1961 and has since been removed. (NYC photograph, Allen County (Ohio) Historical Society collection.)

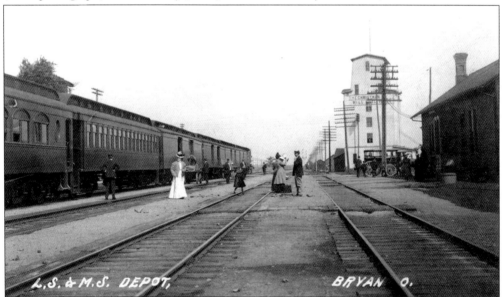

Bryan's frame passenger depot, shown in 1907, dates to 1867 or 1871. A hack waits to take visitors to a downtown hotel. The depot was originally located on the north side of the tracks, opposite the downtown, but as traffic and population grew, it was moved across the tracks to its present location, making it unnecessary to cross the busy tracks. The depot closed as a passenger facility in 1959, but the Railway Express Agency continued to use the building. The c. 1900 brick freight house, west down the tracks, was modified to handle passengers. The depot remains; used for a number of years as a gift shop, it is now looking for a new owner. Across the tracks, Amtrak passengers use a modern shelter. (J.E. Beach photograph, Mark J. Camp collection.)

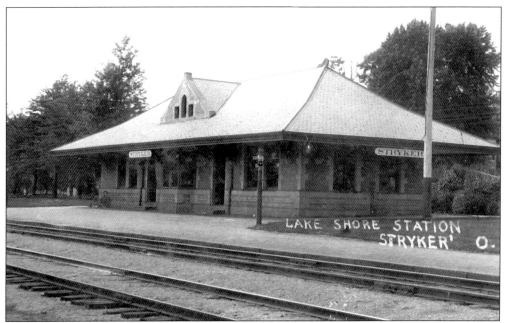

Although not in line for a new depot during a turn-of-the-century LS&MS depot replacement program, Stryker received this depot, pictured around 1905, after the earlier frame depot burned down in 1900. The depot, built on the opposite side of the tracks, eventually became an antique shop. In July 1989, it reopened as a police station and community center. (Mark J. Camp collection.)

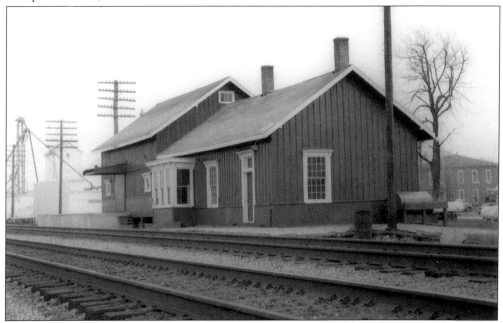

The Archbold community began with the arrival of the MS&NI; for the first years, a boxcar served as the depot. This combination depot was probably built in the late 1860s. This view shows the depot in 1971 after it was converted to local business use. Unfortunately, the building was demolished in the 1980s.

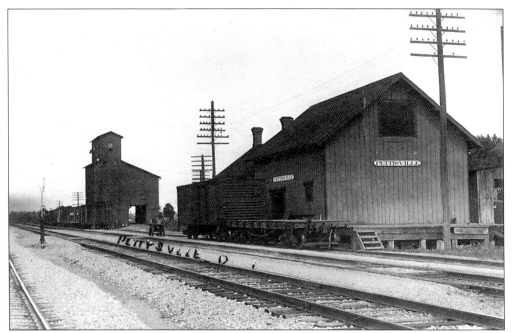

Pettisville's LS&MS depot is of the same plan as Archbold and probably dates to the late 1860s or early 1870s. The passenger end lies hidden behind a boxcar in this c. 1910 view. Down the track is an early grain elevator. Today, the depot is built into the middle of a grain complex. (Mark J. Camp collection.)

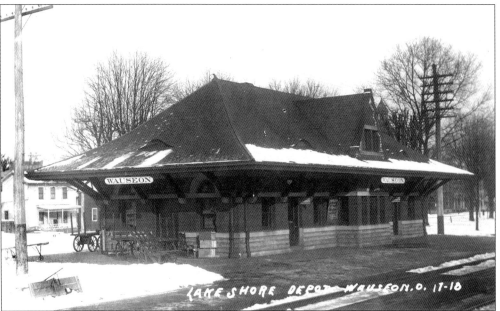

The Fulton County seat of Wauseon received a new LS&MS passenger depot around 1896, replacing an early frame structure. After the passenger agency closed around 1950, the building continued to serve the Railway Express Agency. Then the city bought it for storage use. The building underwent restoration in 1975 to house the Fulton County Historical Society. A barn-like freight station across the tracks is now gone. (Mark J. Camp collection.)

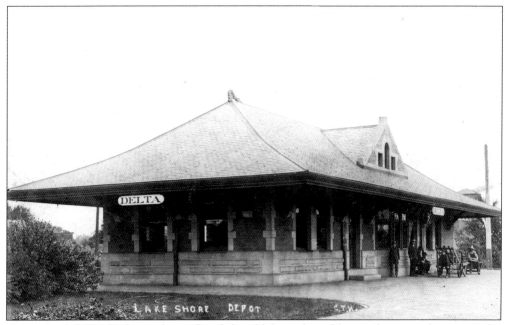

A new brick LS&MS depot also replaced the old frame barn-like combination depot at Delta in 1896. Both depots remain in storage use. (C.T.H. photograph, Mark J. Camp collection.)

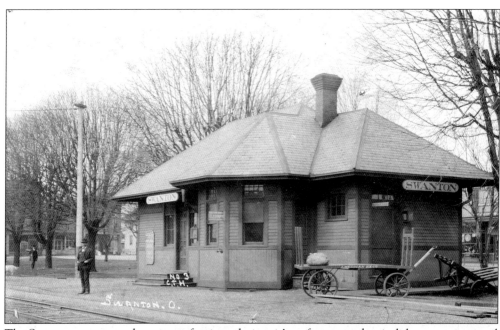

The Swanton passenger depot was of unique design; it's unfortunate that it did not survive until the days of increased public awareness of historic preservation. A LS&MS frame freight house outlived the passenger depot, but alas, it's gone too. Around 1907, the train board fastened to the waiting room end of the depot listed several daily arrivals and departures. (C.T.H. photograph, Mark J. Camp collection.)

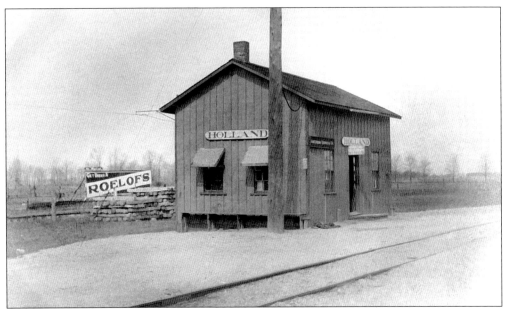

Holland, partially laid out in 1863 and now surrounded by metro-Toledo, was a water stop for LS&MS trains. This small depot once was the lifeblood of the rural community. The depot closed in 1957 and disappeared shortly afterward. (Mark J. Camp collection.)

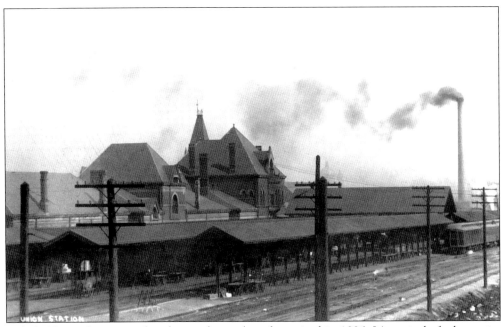

Toledo Union Station replaced an earlier stub-end terminal in 1896. It's typical of a large city passenger depot serving several lines and handling vast numbers of passengers. Central Union Terminal replaced this facility in 1949–50. (Mark J. Camp collection.)

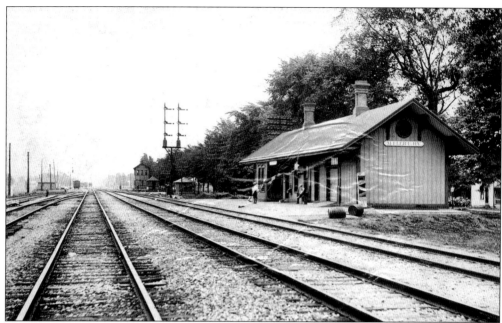

Beginning at Millbury, the junction of the northern and southern routes of the LS&MS between Cleveland and Toledo, the small town depots are built on one basic plan, usually featuring separate passenger and freight depots. The above 1907 and below 1918 views show the characteristics of a *c.* 1870 standard plan—a long building with separate waiting rooms, agents office, and small baggage room. Down the track at the junction is an interlocking tower. Only the small outbuilding between the depot and tower survived into the late 1960s. (Above photograph from the Mark J. Camp collection; below, NYC photograph, from the Allen County (Ohio) Historical Society collection.)

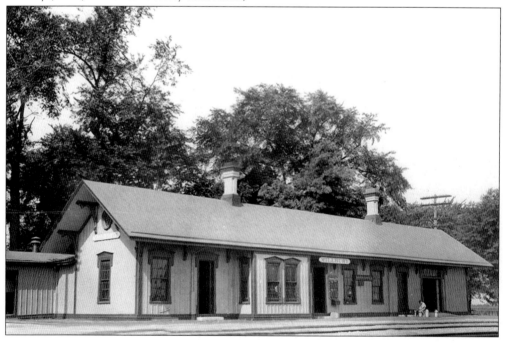

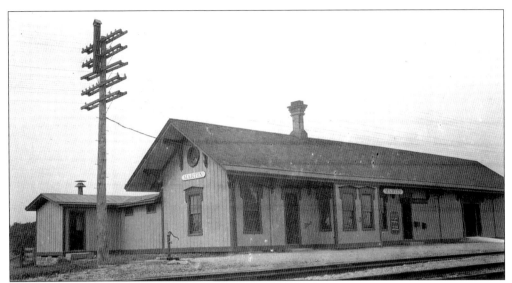

Martin's depot dates to 1872, when the LS&MS resurrected the old northern line of the former Junction Railroad, which had been abandoned and torn up in 1858 between Millbury and Sandusky because of a lack of business and the cost of bridging Sandusky Bay. The depot was gone by the mid-1960s, apparently removed for its lumber. (1918 NYC photograph, Allen County (Ohio) Historical Society collection.)

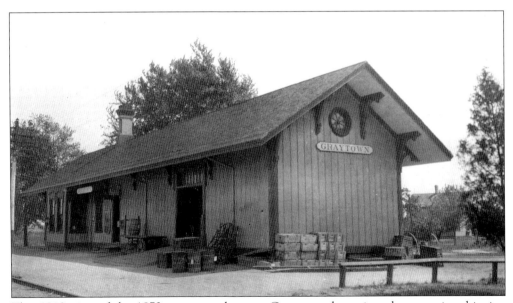

This 1918 view of the 1872 passenger depot at Graytown shows it to be an active shipping point. Closure of the agency came in 1949; the depot was gone by the mid-1960s. (NYC photograph, Allen County (Ohio) Historical Society collection.)

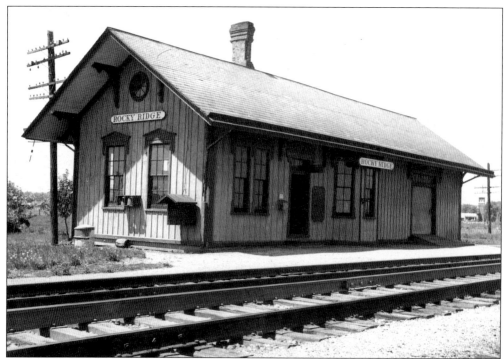

Rocky Ridge also received a LS&MS depot around 1872. The depot continues to serve the NYC in this 1948 view. A phone box is attached to the outside wall. Later, the depot was relocated in town as a tavern; today, it's a residence. (Mark J. Camp collection.)

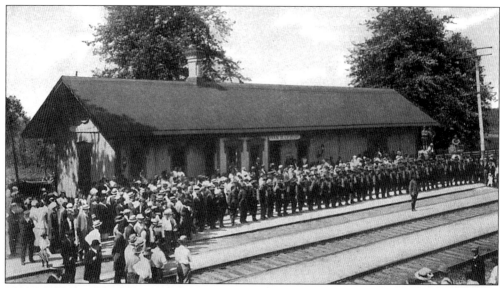

The Oak Harbor LS&MS passenger depot on South Railroad Street was built in the summer of 1872. Here, soldiers wait to board during the Spanish-American War. A freight depot located east of the depot burned down in 1956, however, the passenger depot still serves maintenance forces of CSXT. (Mark J. Camp collection.)

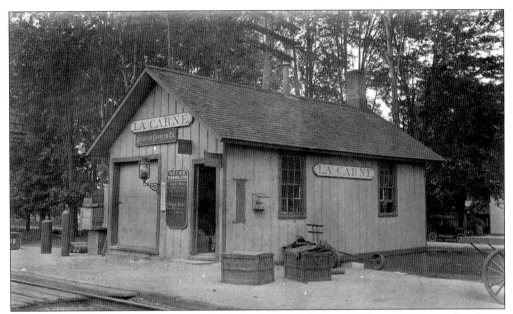

Lacarne's facilities included this utilitarian combination depot, which in 1918 seemed to be an important shipping center. The depot closed in 1959 and was relocated to a lot in town where it remains in storage use. (NYC photograph, Allen County (Ohio) Historical Society collection.)

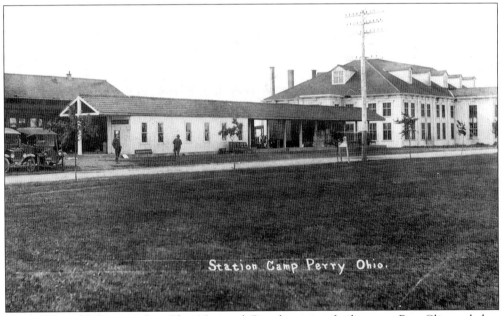

The 1907 establishment of an Ohio National Guard training facility near Port Clinton led to the laying of a spur just east of Lacarne. The Camp Perry depot was basically a covered platform as shown in this c. 1918 view. Although the passenger facilities have been gone for many years, a 1910 freight station was due for restoration, until flattened by a 1998 tornado. (Mark J. Camp collection.)

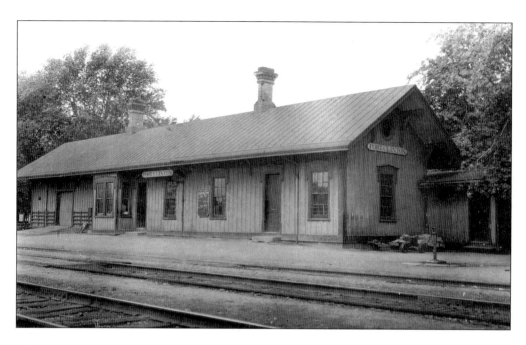

This LS&MS passenger depot was built at Port Clinton in 1872. The upper photograph dates from 1918. In 1928, the scene changed when the track was elevated through town. Passengers then entered the depot at ground level and walked up to track level through a pedestrian subway. Freight and baggage was hauled up on an elevator seen in the 1960s view below. The depot was removed in 1968. (Above, NYC photograph, Allen County (Ohio) Historical Society collection; below, Bob Lorenz photograph.)

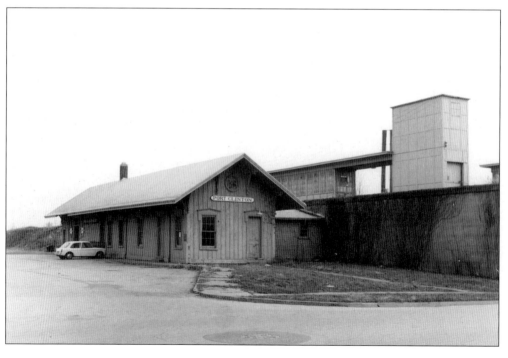

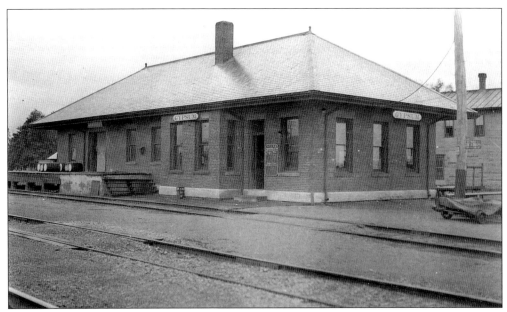

The importance of Gypsum as a fruit-shipping point and mining center on the Marblehead Peninsula explains the brick depot in this small community. The depot, built in 1906, replaced an earlier frame structure dating to 1873. The depot was vacant for years before being demolished in February 1975. (1918 NYC photograph, Allen County (Ohio) Historical Society collection.)

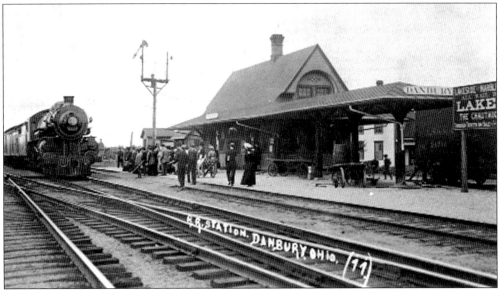

Danbury's first LS&MS depot was a small utilitarian building just north of the railroad's Sandusky Bay Bridge, probably built around 1873. When the Lakeside and Marblehead Railroad opened, this depot was erected at the junction and named Marblehead Junction. Later the name reverted to the original "Danbury." The uniqueness of this depot relates to the fact it was designed by a prominent architectural firm—Shepley, Rutan and Coolidge—rather than the LS&MS engineering office. The depot was well patronized by visitors to the Christian resort at Lakeside. The depot closed in July 1964 and eventually was relocated to Fremont. (Mark J. Camp collection.)

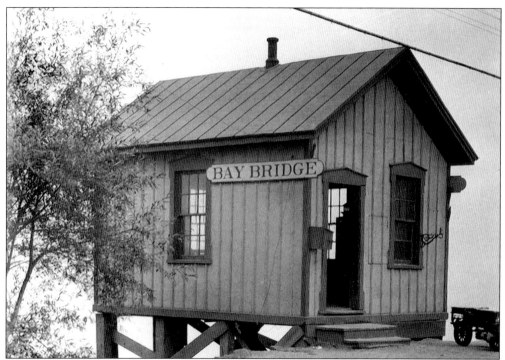

The LS&MS also had a depot, built around 1872, at the south end of their Sandusky Bay Bridge, shown here in 1918. By the time of this photograph, it mainly served as a telegraph office, which closed in 1959. It was gone by the mid-1960s. (NYC photograph, Allen County (Ohio) Historical Society collection.)

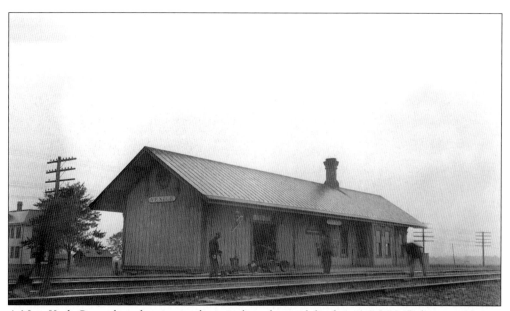

A New York Central track crew tend a switch in front of the former LS&MS depot at Venice in September 1918. The agency closed in 1930; the building was gone by the early 1960s. (NYC photograph, Allen County (Ohio) Historical Society collection.)

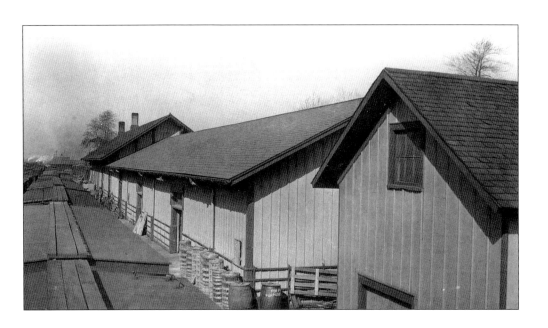

The 1872 Sandusky combination depot (above) was converted to a freight house upon completion of a new passenger depot, seen in the distance. Down the track, on an October 1918 day, a New York Central crew await a train arrival at the new depot designed by the architectural firm of Shepley, Rutan and Coolidge. This stone depot, similar in style to depots on the Boston and Albany Railroad near the home office of the firm, opened in December 1892. Passenger service ended in 1971, and the railroad vacated the building in 1978. After sitting vacant for about 20 years, renovation began in 1998, and the depot now serves as a medical services center and Amtrak stop. The freight house has since been removed. (NYC photograph, Allen County (Ohio) Historical Society collection.)

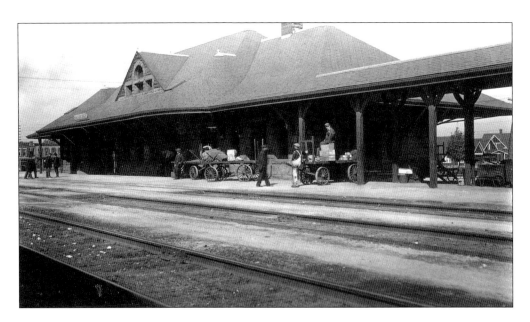

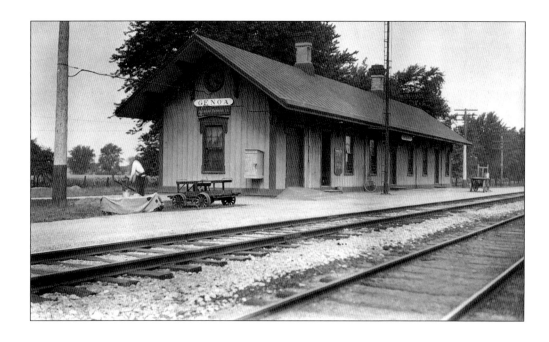

The Genoa and Elmore passenger depots date to 1872 when they replaced earlier combination depots, which became freight houses. Genoa's older depot was also moved across the tracks. Note that the passenger depots, photographed in 1919, differ only in floor plan. Genoa was torn down in January 1972, and the freight house remains in a modified state. Elmore has been restored and continues to serve the community, but the freight house is gone. The rails have been gone since 1986. (NYC photographs, Allen County (Ohio) Historical Society collection.)

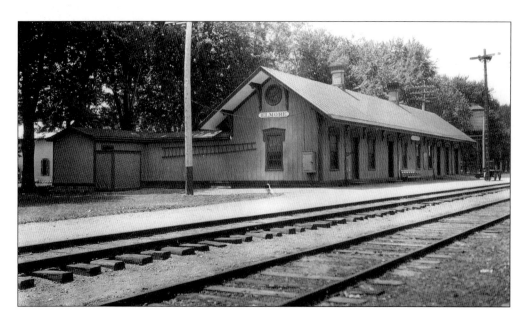

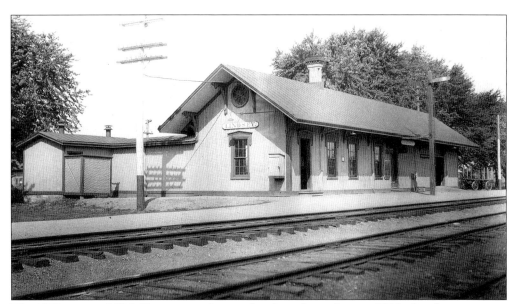

The 1872 vintage LS&MS passenger depot at Lindsey, shown here in 1919, closed as an agency in 1956. By the early 1960s, it had been torn down. (NYC photograph, Allen County (Ohio) Historical Society collection.)

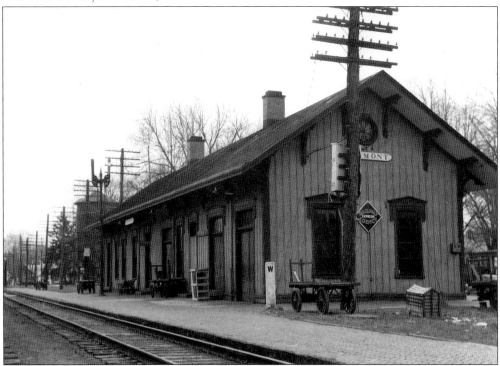

LS&MS built a passenger depot with a wider floor plan in Fremont in the 1870s. Note the water tank and penstock just beyond the depot in this 1947 image. Across the tracks was a large freight station. An octagonal elevated gate tower guarded the road crossing behind the photographer. The passenger depot was used by the Railway Express Agency for a number of years after the depot closed; today, the depot remains in business use. (Clyde Helms photograph.)

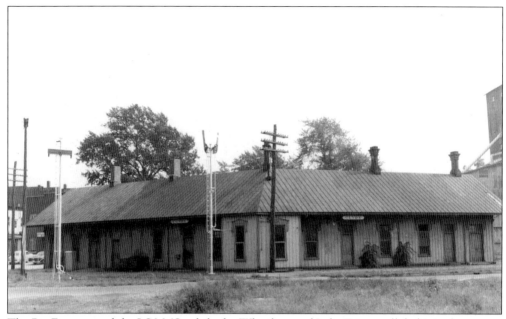

The Big Four crossed the LS&MS, while the Wheeling and Lake Erie paralleled it in downtown Clyde, necessitating this union depot, essentially two standard-plan 1872 vintage depots joined at an angle. At one time, this was a very busy place. This classic building, photographed in 1947, was demolished in September 1960. (Bob Lorenz photograph.)

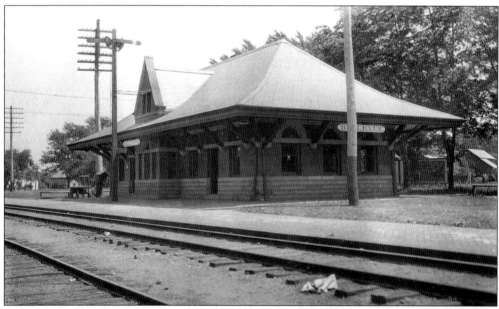

Bellevue's earlier LS&MS depot supposedly was moved nearby and converted into a home when the railroad built this replacement passenger depot in the late 1890s. A companion freight house (now part of the railroad museum) is just down the tracks. The brick depot was demolished before the 1960s. (1919 NYC photograph, Allen County (Ohio) Historical Society collection.)

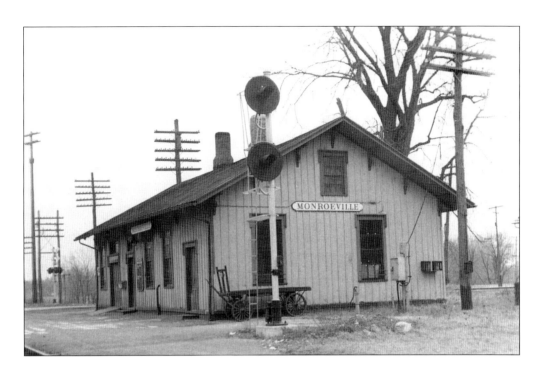

Another wide-design LS&MS depot was built at Monroeville in the 1870s. This depot sat across the road from a combined W&LE-B&O depot and next to the Lake Shore Electric depot. The LS&MS depot is now used by the city. Down the track was the freight depot (below); the original combination depot. (Above, 1947 Bob Lorenz photograph; below, 1919 NYC photograph, Allen County (Ohio) Historical Society collection.)

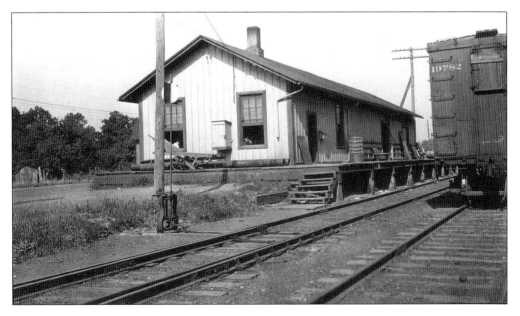

In 1872, the LS&MS erected a new depot in Norwalk (below) and converted the early depot (above), probably of Cleveland and Detroit Railroad ancestry, into a freight house. This 1919 view shows that unlike most depots of this style, the newer depot possessed a bay window. This depot was used by the Railway Express Agency in the 1960s and then later became a business office. Unfortunately, it was demolished in favor of a new store in early 2003. The older depot remains offsite as a store. (NYC photographs, Allen County (Ohio) Historical Society collection.)

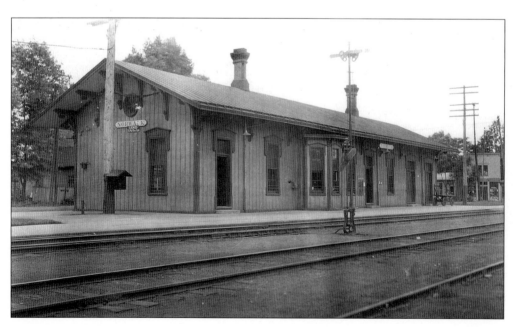

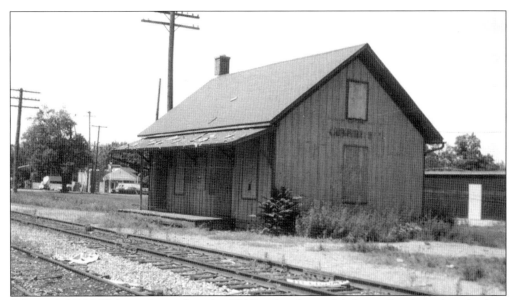

Sylvania's LS&MS depot, located on the Old Road or former Michigan Southern dates back to at least 1868, perhaps even to the 1850s. Passenger service was discontinued in November 1956, and by 1960, the depot was under private ownership. It was moved twice, once in 1970 to become a business office and again in 1997 to the grounds of Sylvania Historical Village. Conrail moved the building on a flat car, reminiscent of many early depot relocations.

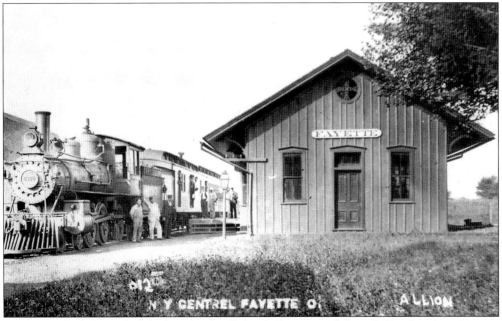

Fayette marked the end of the line for the ill-fated Chicago and Canada Southern's attempt to build a line to Chicago. Facilities around 1908 included this combination depot, dating to 1873, a single stall engine house, and a small turntable at the end of the track. Regular passenger service was replaced by mixed train service in the early 1900s. Passenger service ended in 1938; the track from Morenci, Michigan, to Fayette was abandoned in 1942. (Allion photograph, Mark .J. Camp collection.)

# Toledo and Ohio Central Railroad Depots

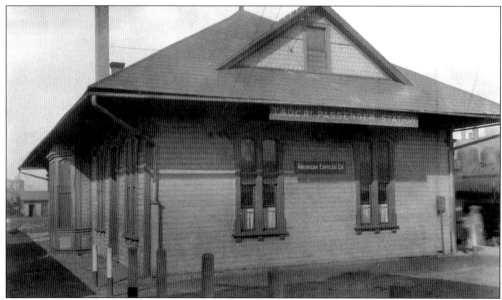

The northern terminus of the T&OC was the stub-end passenger depot, above, located on Main Street in East Toledo. It dates to 1883–1893. Adjacent was a large freight house. Later in the 1900s, NYC abandoned this depot in favor of running passenger trains across the river into Toledo Union Station. The depot, below, served the T&OC and the paralleling PRR at Fassett Street in East Toledo. Nearby was a two-stall engine house used by the PRR. This depot underwent a remodeling in 1913. Both depots have been gone since the mid-1900s. (1918 T&OC photographs, Allen County (Ohio) Historical Society collection.)

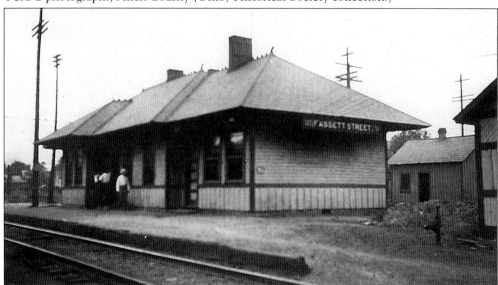

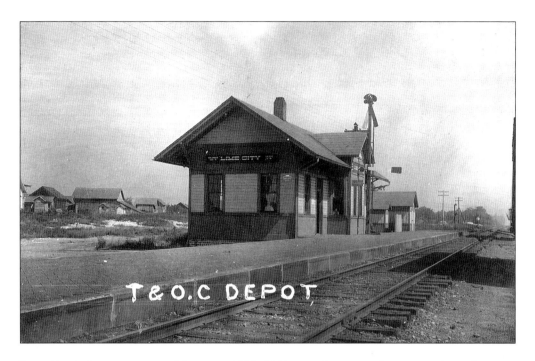

Lime City's depot was erected between 1883–1893 according to a plan repeated at other sites on the line. Note in these early 1900 views that the town boards list mileages to Toledo and Columbus. Also, note the change in paint schemes. The local stone quarries kept the freight office busy for many years. The agency closed in 1958, and by the 1960s, the depot was relocated nearby and converted to a radio station. (Mark J. Camp collection.)

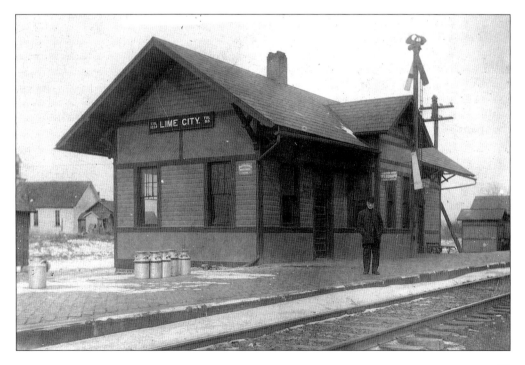

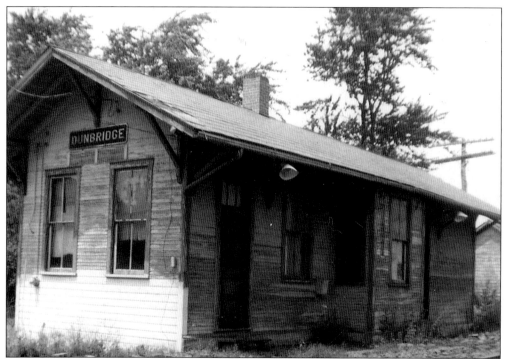

Dunbridge's depot exhibits another plan used by the railroad. It probably dates from the 1880s. Note that in this 1966 view, the town boards have been replaced by the cast iron signs symbolic of the NYC of the mid-1900s. A year after this picture was taken, the depot was torn down.

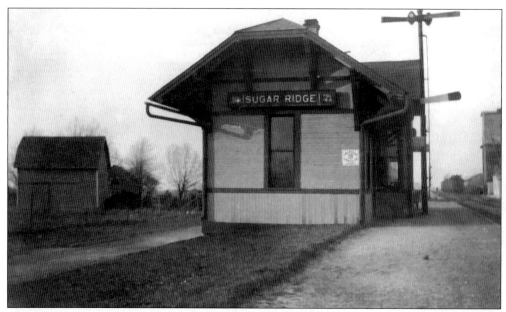

The presence of a hipped roof makes the Sugar Ridge depot design appear different, but it's basically the same as Lime City. The agency closed in 1950, and by the 1960s, the depot had been relocated and transformed into a residence. (Mark J. Camp collection.)

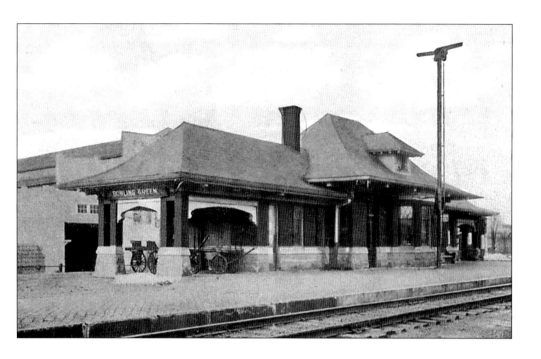

Bowling Green, being the county seat and home to a university, needed this larger depot to handle the increased business. It dates to 1896. Photographed around 1910 and 1949, the depot lasted until April 1962. Nearby was a frame freight house, torn down in March 1971. (Mark J. Camp collection.)

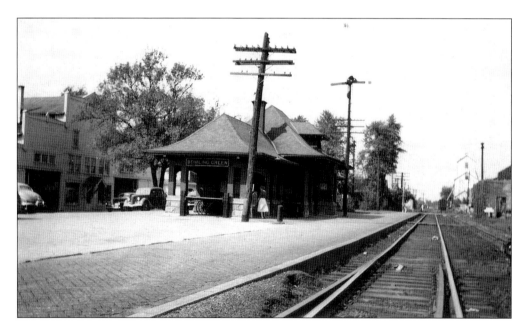

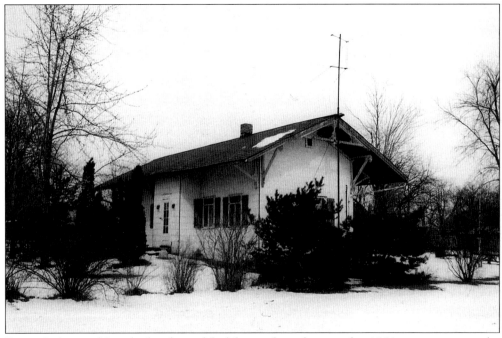

Portage's depot, although already modified for residential use in this 1964 view, preserves the trim in the eaves, suggesting it probably dates to the 1880s. The agency closed in 1949. Since then, the building has been moved twice. (Charles Garvin photograph.)

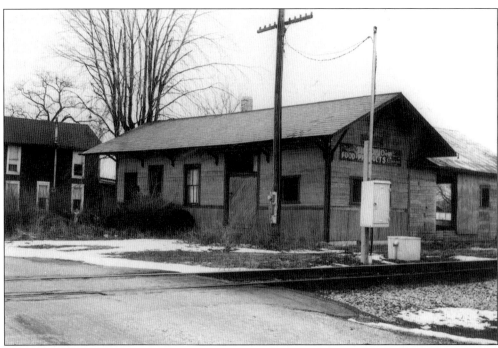

Mermill closed in 1955 and was relocated to serve a local business. By this 1966 view, it had been abandoned; three years later, it would be gone. (Charles Garvin photograph.)

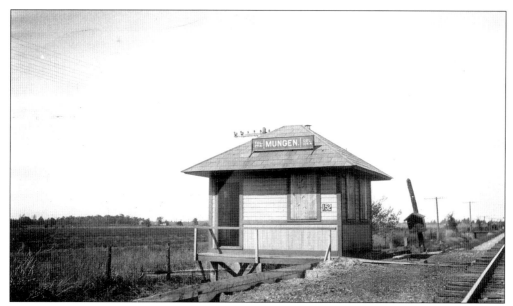

This structure at Mungen, between Mermill and Cygnet, is an example of a small T&OC telegrapher's cabin. By this 1918 view, the railroad had removed the operator; only the concrete base of the order board remains. (T&OC photograph, Allen County (Ohio) Historical Society collection.)

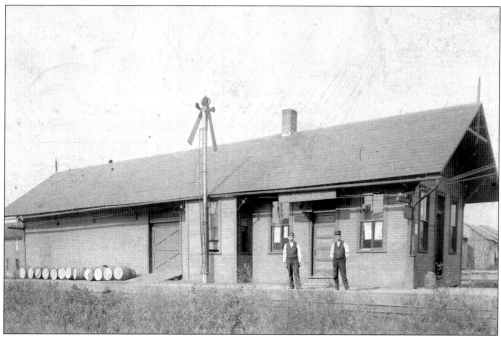

The agent and his assistant pose for a photographer outside the depot at Cygnet around 1910. Cygnet formed as the Toledo and Indianapolis Railroad laid track; the depot opened in 1883. The nearby oilfields (note the barrels) kept the staff busy. The agency closed in 1960, and the depot disappeared in the 1970s. (Mark J. Camp collection.)

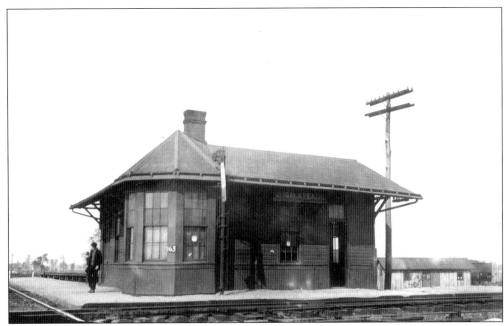

The crossing of the T&OC and B&O was named Galatea. The joint depot probably dates to 1883. Across the tracks was an interlocking tower and an L-shaped transfer freight house. All are now gone. (1918 T&OC photograph, Allen County (Ohio) Historical Society collection.)

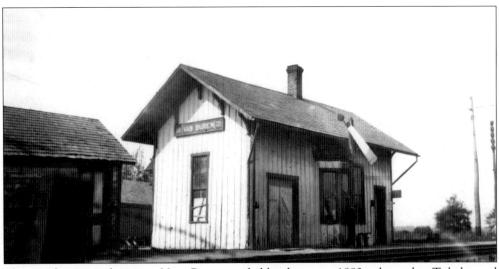

The combination depot at Van Buren probably dates to 1883 when the Toledo and Indianapolis Railroad opened between Toledo and Findlay. It was gone by the 1950s. (1918 T&OC photograph, Allen County (Ohio) Historical Society collection.)

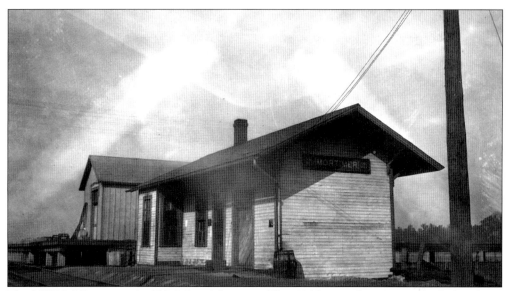

The NYC&StL crosses the T&OC at Mortimer. This 1918 view shows a standard-plan depot and a transfer freight house. Across the diamond was a frame interlocking tower. The New York Central closed its Mortimer agency in 1955; however, this depot burned down in the late 1940s. (T&OC photograph, Allen County (Ohio) Historical Society collection.)

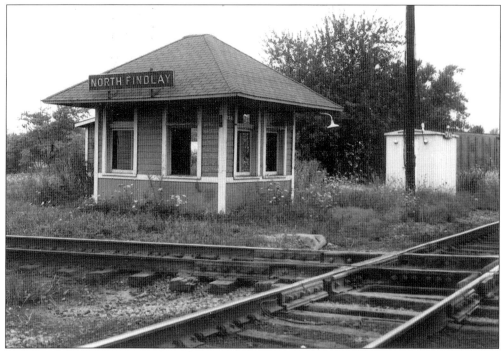

On the northern edge of Findlay, the Lake Erie and Western Railroad crossed the T&OC at a station called North Findlay. By 1966, the small tower at this diamond sat abandoned and stripped of its order board. (Charles Garvin photograph.)

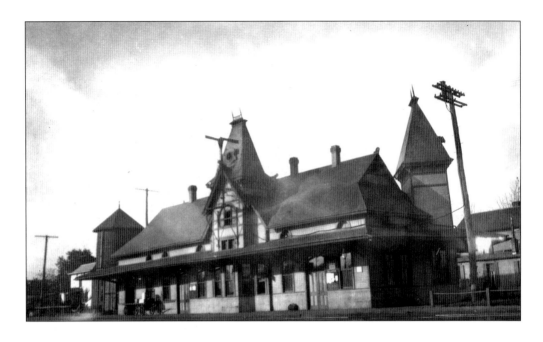

These views taken in 1918 (above) and 1966 (below) show the impressive passenger depot at Findlay. The building probably dates to 1883 when it served as the southern terminus of the Toledo and Indianapolis Railroad. Through the years, the NYC stripped the depot of its gothic towers and modified the doors and windows. Nearby was a separate freight house. Unfortunately, both depots were gone by the 1970s. (Above, (T&OC photograph, Allen County (Ohio) Historical Society collection.)

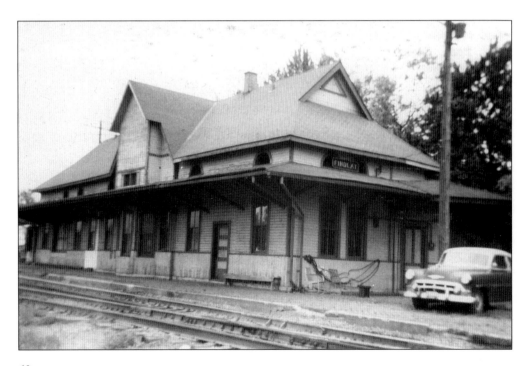

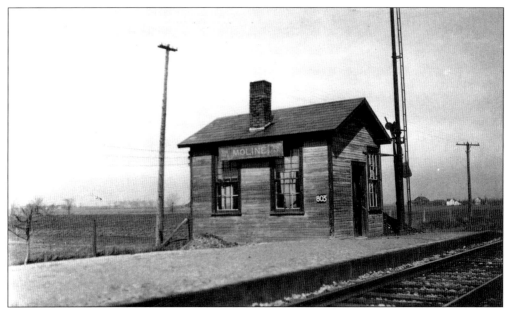

The other T&OC line out of Toledo was the former Ohio Central, responsible for this small depot at Moline. The operator had a decent pile of coal to feed his pot-belly stove during the winter of 1919. (T&OC photograph, Allen County (Ohio) Historical Society collection.)

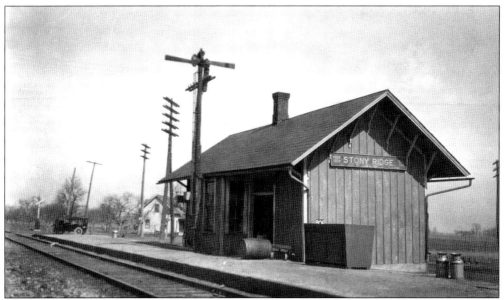

The agency at Stony Ridge closed in 1958, and shortly after, the depot was moved offsite. After serving as an antique shop for a number of years, it is now hidden from view on private property. Note that the agent in 1919 rode a bike, perhaps a good choice since the motorist in the background has his hood up. (T&OC photograph, Allen County (Ohio) Historical Society collection.)

Luckey's depot probably dates to 1881–82. It remained an open agency for eighty years. The depot was removed in 1965; Penn Central ceased using the track in 1976. (1919 T&OC photograph, Allen County (Ohio) Historical Society collection.)

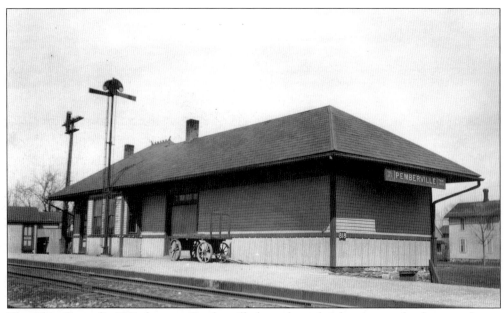

The Ohio Central's 1881 depot at Pemberville has a large freight room and a fancy roof crest above the office and waiting room. After closing in 1959, the depot was used for storage until it underwent private restoration as a museum in the mid-1980s. (1919 T&OC photograph, Allen County (Ohio) Historical Society collection.)

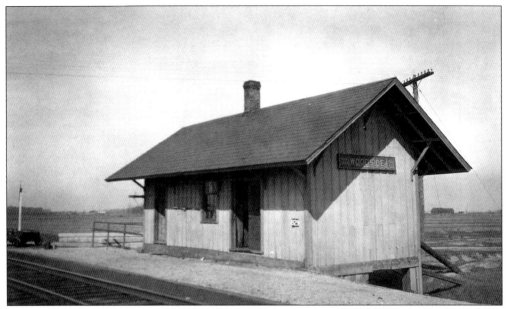

This small utilitarian combination depot was sufficient for the business generated at Woodside, between Pemberville and Prairie Depot (Wayne). It was open from the 1880s until the mid-1900s. (1919 T&OC photograph, Allen County (Ohio) Historical Society collection.)

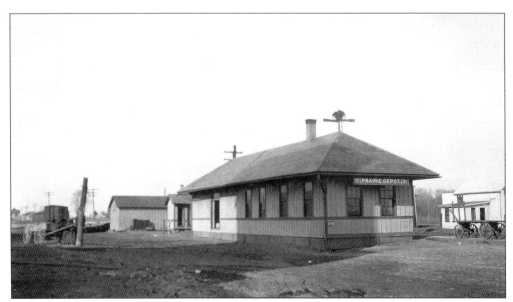

By 1919, much of the tall grass prairie around Prairie Depot had succumbed to the plow and field tile. The combination depot dates to the 1880s. The depot became part of a residence in what is now called Wayne by the 1960s. (T&OC photograph, Allen County (Ohio) Historical Society collection.)

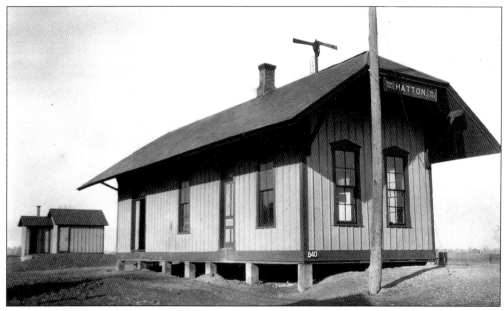

For a tiny community, Hatton, located between Wayne and Fostoria, had one of the more attractive small town depots in northwest Ohio. The depot closed in 1959. It was moved offsite, and after some years housing collectibles, it fell into disrepair. It's future appears bright, as restoration is hopefully on the horizon. (1919 T&OC photograph, Allen County (Ohio) Historical Society collection.)

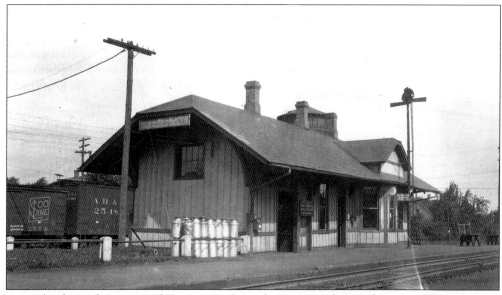

Around a dozen depots served Fostoria in the early 1900s, including this one of Ohio Central heritage. Note the similarity of this depot plan to that of many Hocking Valley Railway depots. The three chimneys served separate waiting rooms and the intervening agent's office. The depot was boarded up and served storage purposes after closing. Recently, it burned down. (1919 T&OC photograph, Allen County (Ohio) Historical Society collection.)

# *Three*

# NICKEL PLATE
# LINES

The New York Chicago and St. Louis Railroad Company, commonly known as the "Nickel Plate," opened between Buffalo, New York, and Chicago, Illinois, October 22, 1882, stretching across northwest Ohio from Erie to Paulding Counties. Expansion of the NYC&StL in 1922 brought the former Lake Erie and Western and Toledo, St. Louis and Western Railroads under its umbrella. The Lake Erie and Western began with a line heading southwest from Fremont in 1853. The main line reached Sandusky in 1880 and Peoria, Illinois, in 1888. The Toledo, St. Louis and Western, nicknamed the "Cloverleaf" and connecting Toledo with East St. Louis, Illinois, formed in 1900 from the reorganization of the Toledo, St. Louis and Kansas City Railroad, which in turn, evolved from the consolidation of several narrow gauge lines, dating back to 1874. The Wheeling and Lake Erie Railroad Company, the last of the lines to come under Nickel Plate control in 1949, was chartered in April 1871 to construct a line between Lake Erie and the Ohio River. The main line reached Toledo August 24, 1882. A branch from Milan to Huron opened earlier in January 1882.

Each of these companies existed long enough to establish recognizable architectural patterns in their buildings, particularly depots and towers. Most served the railroad until their retirement or removal, and only a few replacement depots appeared after the 1880s. In the summer of 1881, the NYC&StL adopted three standard sizes for passenger depots: 18 feet by 40 feet, 24 feet by 50feet, and 28 feet by 60 feet, based on population. Some 25 depots of this design, built between the fall of 1881 and August of 1882 and opened in October 1882, served northwest Ohio communities; unfortunately, only the Payne depot remains. The LE&W, TStL&W, and W&LE depots show a wider variation in designs, and repetitive plans are not greatly evident in northwest Ohio. LE&W depots were frame and date to the late 1880s. Amsden, Castalia, Findlay, Fostoria, Fremont, and Vickery survive, adapted to other uses, with the exception of Fremont. TStL&W depots followed several standard plans, repeated at distant intervals. Aside from their terminal at Toledo, all their depots in northwest Ohio were frame combination structures. Fort Jennings, Maumee, Malinta, North Creek, Pleasant Bend, and Waterville survive. W&LE management used brick, stone, and wood in their northwest Ohio depots. Larger passenger depots graced Fremont, Norwalk, and Toledo; combination depots built to several standard plans marked in-between stations. Only Curtice and Monroeville remain; both have been moved to new locations.

October 16, 1964, marked the end of the Nickel Plate when it, along with the Akron, Canton and Youngstown, Pittsburg and West Virginia, and Wabash, merged with the Norfolk and Western Railway. Remaining northwest Ohio parts of the Nickel Plate lines are now part of the Norfolk Southern System and new Wheeling and Lake Erie.

# New York, Chicago and St. Louis Railroad Depots

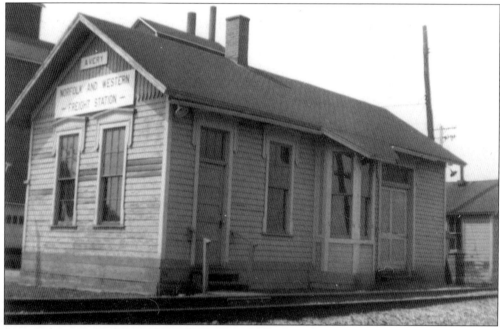

Avery's depot opened in 1882, but not in this 1967 guise. The NYC&StL carpenters cut back the roof overhang to reduce maintenance costs. The depot closed in 1967 or 1968. In later years, it was also the local post office. It was demolished in 1969.

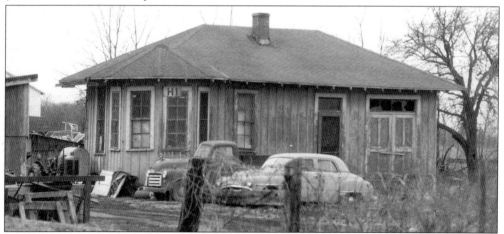

The B&O line to Sandusky crossed the Nickel Plate at Kimball. The depot, pictured here in 1969, was a joint agency and also served as a tower when located at the diamond. Reportedly, the depot has been dismantled for future reconstruction elsewhere. (Charles Garvin photograph.)

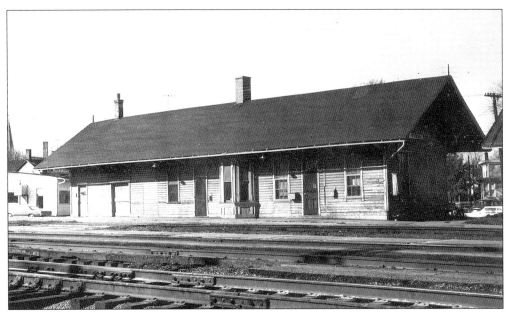

Bellevue became the Middle Division terminal of the Nickel Plate in 1882. Facilities included a large roundhouse, shop buildings, and coaling station, besides passenger and freight depots, and a lunchroom. The depot, shown in 1965, received an addition on the far end. The Bellevue terminal was redone and expanded in the mid-1940s and again in the 1960s. The depot and adjacent lunchroom were torn down in 1967. (Howard Ameling photograph.)

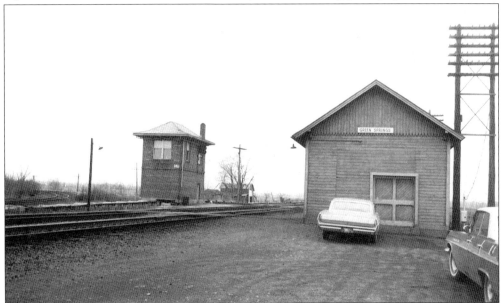

A somewhat modified combination depot dating to 1881–82 and brick GR Tower (built by the Nickel Plate around 1923) once sat at the crossing of the Nickel Plate and Big Four in Green Springs. Although the Big Four depot was downtown, the NKP facilities were south of town at Green Springs Junction, necessitating a hack connection to downtown and the health resorts. The depot closed in 1971 and was demolished by the mid-1970s. GR Tower lasted until 1985. (1967 Charles Garvin photograph.)

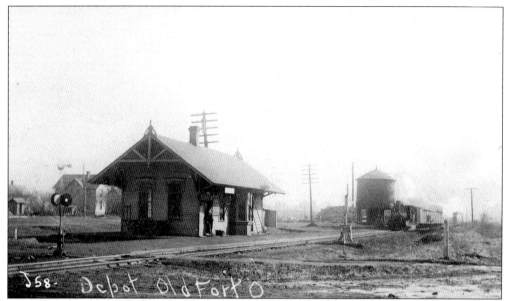

Old Fort Seneca, named after nearby Fort Seneca, was platted in 1882 as the Nickel Plate opened. The railroad built one of their standard-plan depots and originally called it Fort Seneca. The town later became known as simply Old Fort, and the railroad finally avoided confusion by changing the name of the station as well. A freight locomotive takes water just beyond the depot in this *c.* 1907 view. Old Fort was closed in 1962 and removed before 1970. (Mark J. Camp collection.)

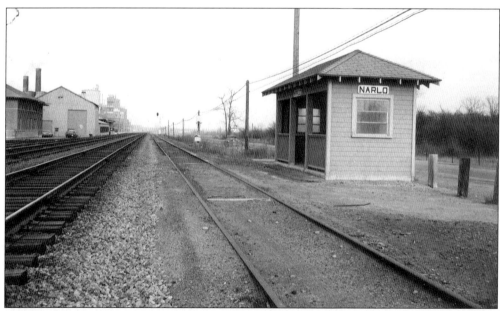

Quarries west of Old Fort yielded a stone greatly suited for refractories. One of the early companies working this stone was the Holran Co. The Nickel Plate spelled the company name backward and dropped the "h" to come up with the station name of "Narlo." This three-sided shelter was built for the convenience of the company in the mid-1900s. (1969 Charles Garvin photograph.)

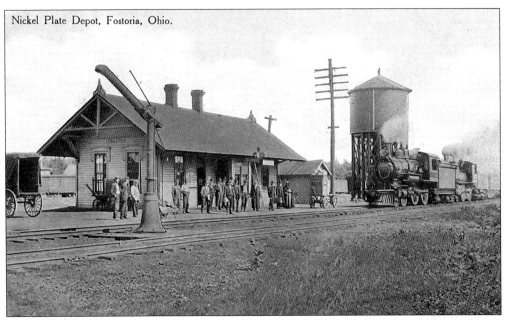

Nickel Plate Depot, Fostoria, Ohio.

Fostoria was an important interchange point for the NYC&StL, as four other railroads converged here. A crowd awaits a train in this *c.* 1910 view. The depot was removed in March 1967. (Mark J. Camp collection.)

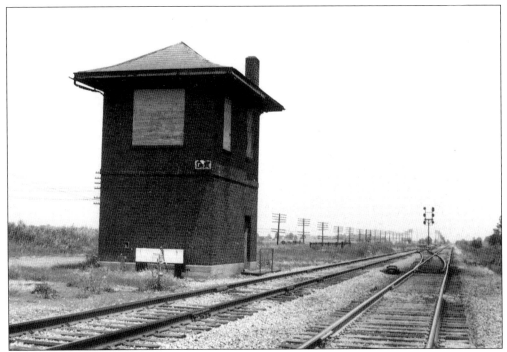

Arcadia's depot was much like Fostoria and has since been turned into a house. Near town was DA Tower, put in service in 1924 and removed in the 1970s.

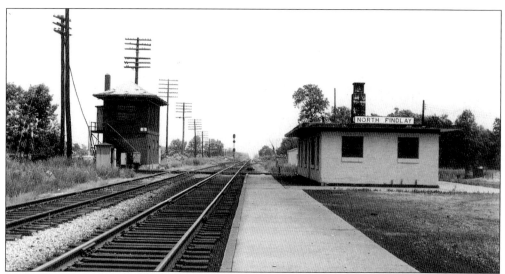

Looking east down the Nickel Plate in 1965 at Mortimer (renamed North Findlay in 1947 by the Nickel Plate) is S Tower and the former passenger depot. The tower was erected around 1938 to replace the old frame T&OC tower. The depot dates to 1948–49 and was erected for the convenience of Ohio Oil Company officials in Findlay when the previous depot burned down. The depot was only used briefly for passengers, as the oil company opened their own airport shortly after. Only the depot remains and is now used by maintenance crews. (1965 Charles Garvin photograph.)

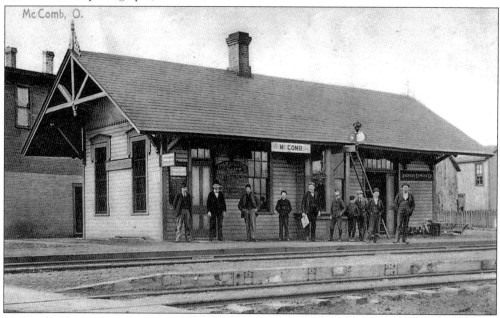

McComb's depot closed in 1968 and was used by a furniture company until its demolition. This 1910 view shows the detail of the NKP-style order board, consisting of four radiating reflectors that can be rotated by the depot staff to appear white or red to approaching trains. Above the reflectors is a switch lantern with colored lenses for night-time use. Note the ladder for access. McComb has the distinction of hosting the first NKP train July 4, 1881, when an excursion ran over the first 15 miles of newly laid rail. (Mark J. Camp collection.)

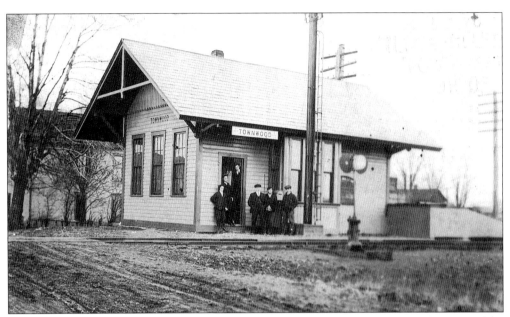

Nickel Plate standard-plan depots could be shortened or lengthened depending on the size of the community. Townwood had a short version, but featured a non-standard semaphore-type order board and an elevated freight platform to the right. Note that the staff had to climb the ladder to set the signal. The depot was torn down around 1940. A siding for pre-paid freight remained until 1947 when the Nickel Plate closed the site as a station. (Mark J. Camp collection.)

Due to the presence of an important poultry firm, the Nickel Plate placed a standard depot in West Leipsic and adapted it for freight use only. Passengers were handled east a short distance at the CH&D–NYC&StL Leipsic Junction depot. When the poultry firm shut down, the railroad moved the freight house to the wye at the junction. It has since disappeared. (Mark J. Camp collection.)

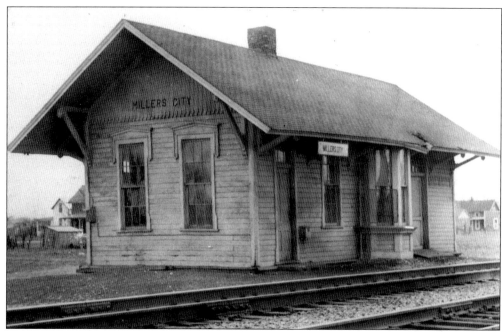

Although stripped of gable ornamentation, platform, order board, and other features of an operating depot, Miller City depot retains much of its 1882 appearance here in 1953, three years after it closed. (David Longsworth photograph, Allen County (Ohio) Historical Society collection.)

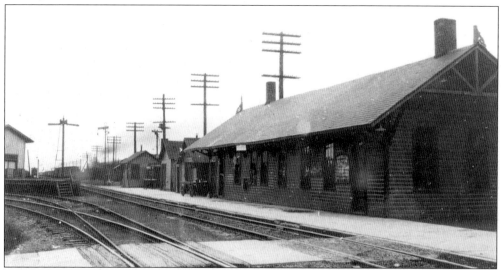

The TStL&W crossed the NYC&StL at Continental. A depot was opened here in 1882; across the tracks was a transfer freight house. Around 1905, the depot was lengthened, an additional baggage shed was added, and a single-story tower was built at the junction beyond the depot. At some point, the baggage sheds were replaced by a separate baggage building between the depot and the junction. A 1947 derailment wrecked the baggage building; it was not rebuilt. The latest modification was the addition of a bay window at the east end of the depot, replacing the tower. Although there was talk of converting the depot to the town library, the depot was torn down in the early 1980s. (Mark J. Camp collection.)

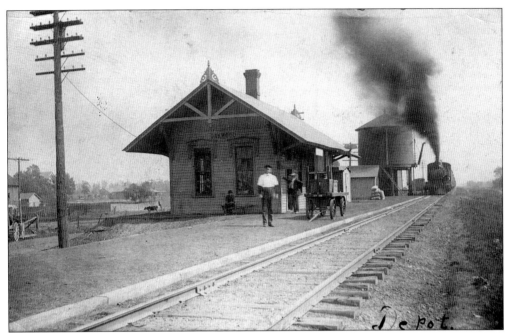

This 1910 view at Oakwood looks east to an arriving local freight. American Express parcels await the train on the baggage cart. The depot closed in 1969 and has since been torn down. (Mark J. Camp collection.)

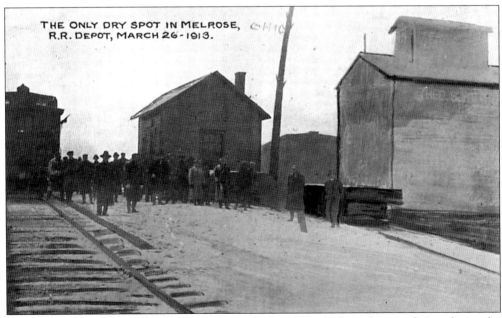

This highly retouched postcard was exposed under less than ideal weather conditions during the 1913 Flood. The Melrose depot is one of Nickel Plate's portable structures, designed to be easily relocated by flatcar. (Mark J. Camp collection.)

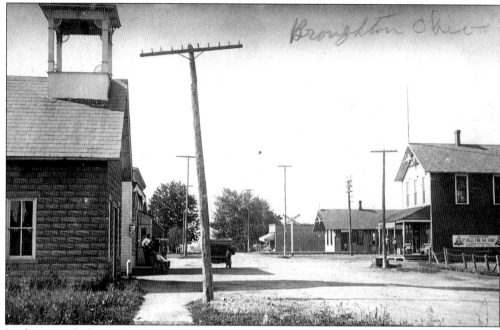

Looking south down the main street in Broughton, the NYC&StL depot can be seen. This agency closed in 1949. The depot's gone, but some of the other buildings remain. Just down the line at Briceton, a similar depot closed in 1930. (Mark J. Camp collection.)

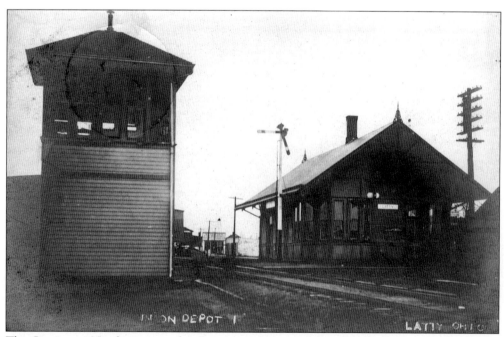

The Cincinnati Northern crossed at Latty, another town platted with the arrival of rail. The depot has two bay windows, but is otherwise similar to the CN standard plan. The tower was removed around 1950, and the depot in 1969. (Mark J. Camp collection.)

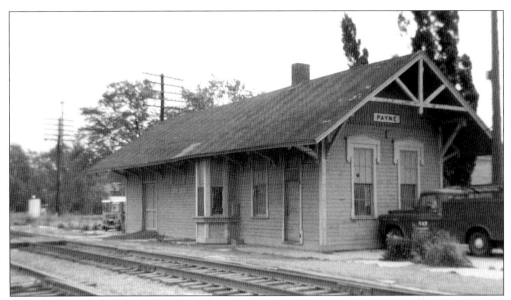

Payne is the only NYC&StL depot of standard design left standing in northwest Ohio. In this 1967 view, the depot was still in use by the N&W maintenance forces. The depot now resides in the town park.

# Lake Erie and Western Railroad Depots

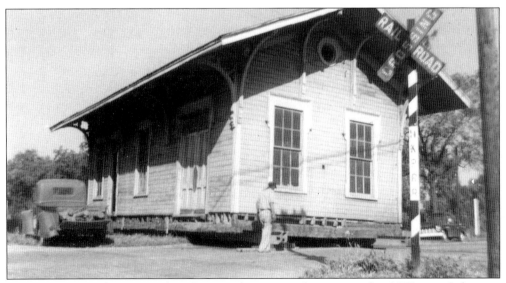

Castalia's LE&W depot is ready to be moved to its new location in this 1970 view. It became a residence and later a business club. (Mark J. Camp collection.)

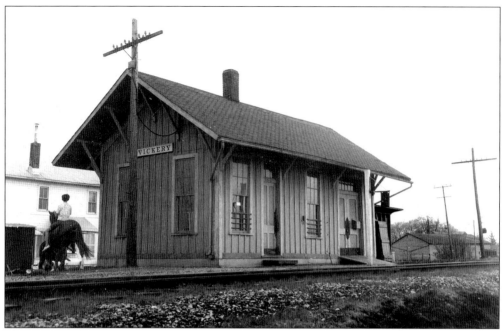

The Vickery depot plan was used at a number of small towns along the LE&W and dates to 1880–1881. Note the protective bars on the lower sashes, a feature common to many LE&W structures. The agency closed in 1965–1966 and was moved in May 1967 to the edge of town for camp use. (1964 Bob Lorenz photograph.)

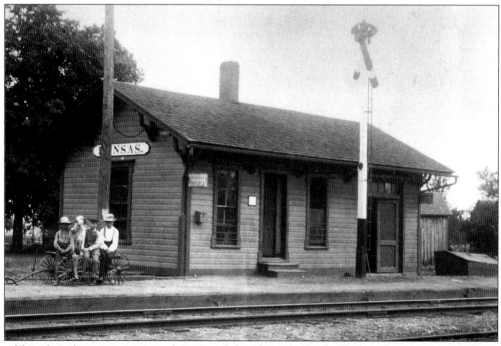

Although in between trains at the time of the photograph, the Kansas depot was a gathering spot for local youth and their dog. After closing in 1959, the depot was relocated to the Fostoria yard where it was used for storage. It has since been removed. (Bob Lorenz collection.)

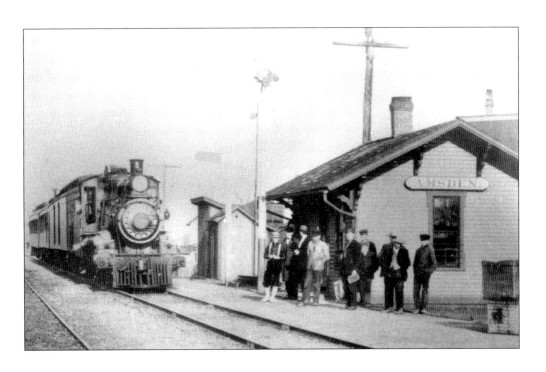

Except for the scalloped roof brackets, the Amsden depot is rather plain. Comparison of these two views show little change to the building in some 50 years. The agency closed in 1958; later, the depot was relocated. It remains in residential use today. (Bob Lorenz collection.)

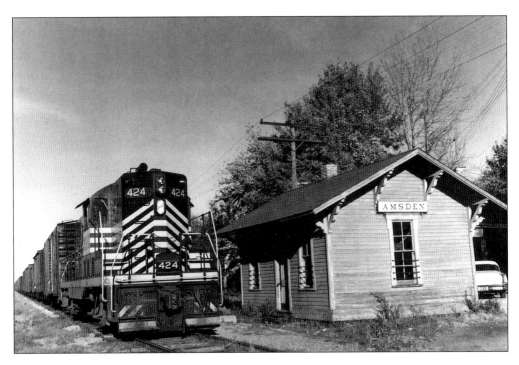

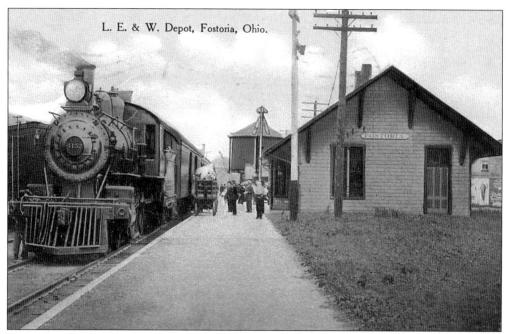

Baggage and passengers are being loaded at Fostoria's 1879 LE&W passenger depot around 1910. Passenger service between here and Sandusky was discontinued in the fall of 1929. After the freight agency closed, a feed company operated out of the building until 1970. Although the track is gone, the depot is now restored. (Mark J. Camp collection.)

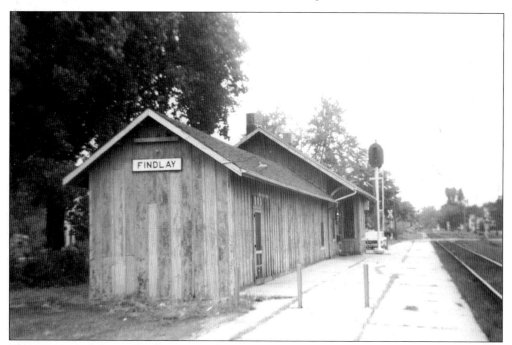

The passenger depot in Findlay received an addition or two after its completion in the 1880s. A separate freight station and a one stall engine house were nearby in this 1966 view. Only the freight house remains.

# Toledo, St. Louis and Western Railroad Depots

The northern terminus of the TStL&W, or Cloverleaf, was on the south edge of downtown Toledo. This building was constructed as a freight station in 1907, but it also handled passengers for the Cloverleaf's Commercial Travelers from the Great Depression to the end of passenger service in 1941. Freight offices of a number of lines occupied the building until 1980. It was taken down in spring of 1986. This view dates to 1972.

Maumee's TStL&W combination depot, probably built between 1876 and 1880, closed in 1958. After use by a local lumberyard, the depot awaits a move to the Wolcott House Museum grounds to become part of the Maumee Valley Historical Society's historical village in November 1971.

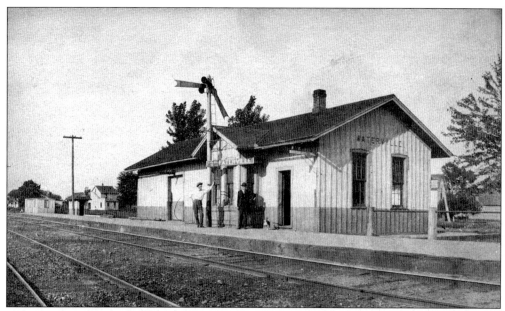

The combination depot at Waterville was reportedly erected around 1876. At some point after the early 1900s, the freight room was removed, greatly shortening the building. After the discontinuance of passenger service, the former waiting room became a garage for a track car. The tourist line Toledo, Lake Erie and Western eventually acquired the depot and former Cloverleaf trackage from Waterville to Grand Rapids. (Mark J. Camp collection.)

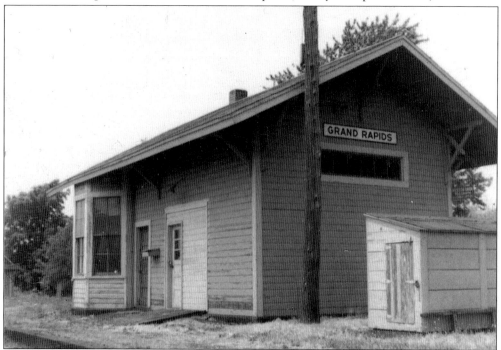

The Cloverleaf depots did follow several standard plans, but plans were not often repeated at close intervals. Grand Rapids depot is of yet another design. This view in 1966 was taken shortly after the agency closed and less than a year from its demolition.

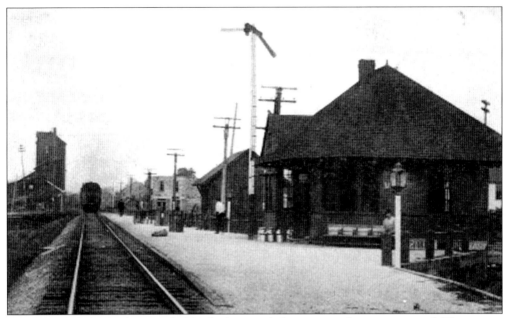

McClure, probably built around 1880, had a rounded corner on the passenger end. The agency closed in 1965, and the building was removed in 1967. (Mark J. Camp collection.)

Looking down the main street of 1908 Grelton, the Cloverleaf depot is seen on the left. This depot has been gone for many years. (Mark J. Camp collection.)

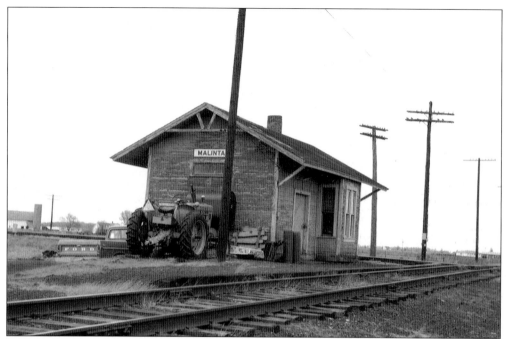

At Malinta, the former Detroit and Lima Northern (later DT&I) crossed the TStL&W. Of yet another style, the depot shown here in 1971 sat across from an interlocking tower and served as a joint depot in the early years. In 1980, it was moved to Grand Rapids to become a ticket office for the Toledo, Lake Erie and Western Bluebird Special. When difficulties arose with village officials and demolition was threatened, the depot was moved back to Malinta in the fall of 1980. A newly organized Malinta Historical Society restored the building as their museum.

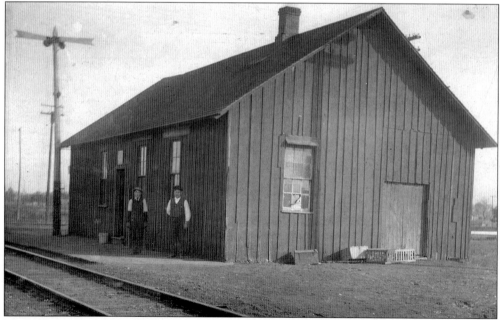

The rather spartan Cloverleaf depot at Holgate shared the diamond with a B&O depot and interlocking tower. The depot was gone by the mid-1900s. (Mark J. Camp collection.)

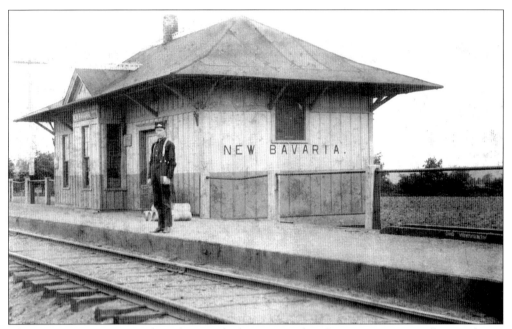

The agent at New Bavaria kept busy with the many tasks of maintaining a small town depot. Cloverleaf depots by the early 1900s had a two-tone paint scheme. When it was removed in the late 1960s, it was painted gray. (Mark J. Camp collection.)

Pleasant Bend's depot was built to the same plan as Malinta and North Creek, probably in the early 1880s. It was relocated for private use as shown in this 1971 view. Now, it's a residence in Miller City.

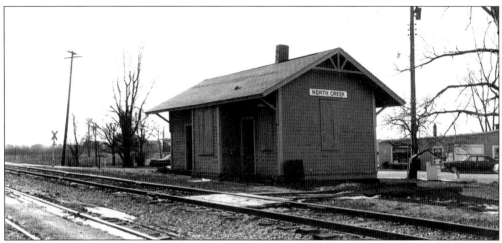

North Creek was boarded up after the agency closed and was moved around 1987 to a small airport for office use. Note the similarities to Malinta and Pleasant Bend. (1967 Charles Garvin photograph.)

# Wheeling and Lake Erie Railroad Depots

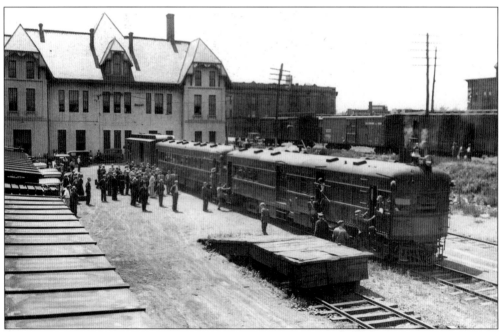

The W&LE opened this passenger depot at 1008 Cherry Street in Toledo in 1882. This trackside view of the stub-end terminal shows W&LE Number 3 about to leave on its last run to Zanesville on May 31, 1932. The building was removed in February 1941. (Gustave Erhardt photograph.)

The W&LE replaced their 1880 vintage Front Street yard office in Toledo (on the left) with this modern building in 1949. The frame building, once the Ironville depot, sat across the track until 1916. The new yard office was gone before 50 years passed. (Gustave Erhardt photograph.)

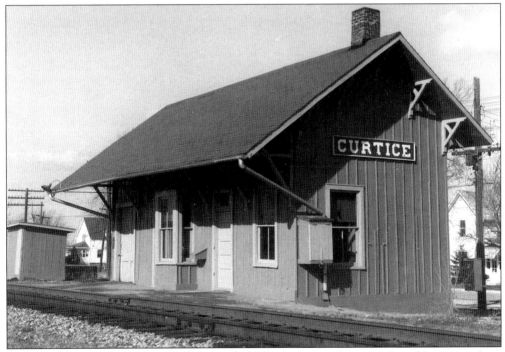

The plan of the Curtice depot (built around 1881) was repeated at a number of locations along the W&LE. In the late 1960s, a derailment damaged the waiting room end. After repair, the agency remained open until 1972. It was relocated to the Mad River and NKP Railroad Museum in Bellevue in 1976. (Mark J. Camp collection.)

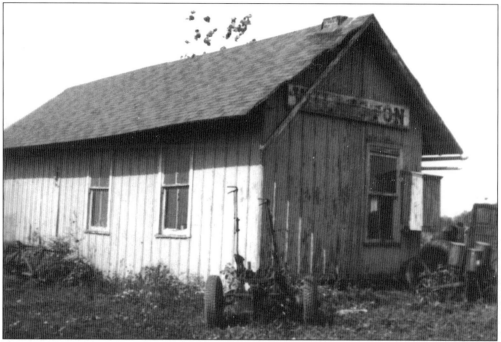

The depot at Williston closed in 1957 and was shortly moved to a farm near Bono for storage purposes. This view dates to 1966.

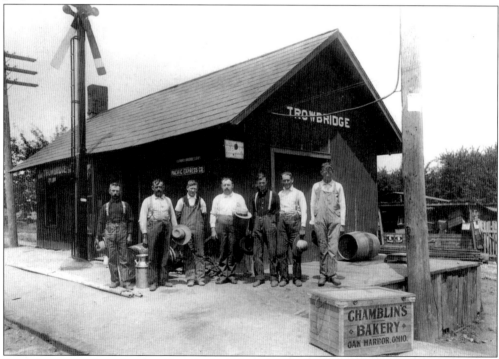

A section crew takes a break at Trowbridge. Note that the W&LE originally stenciled the town name on the end of their depots. This depot closed in 1961 and has since been demolished. (Kirk Hise collection.)

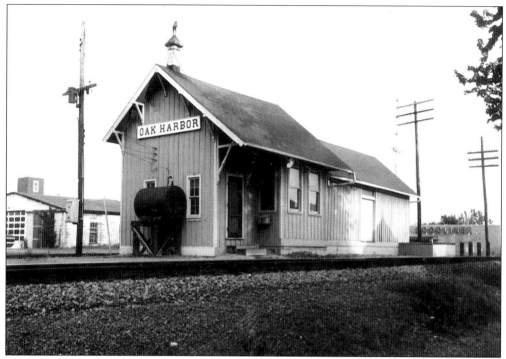

The W&LE combination depot on Water Street in Oak Harbor dates to 1882. The agency closed around 1985 and demolition followed shortly. (Charles Garvin collection.)

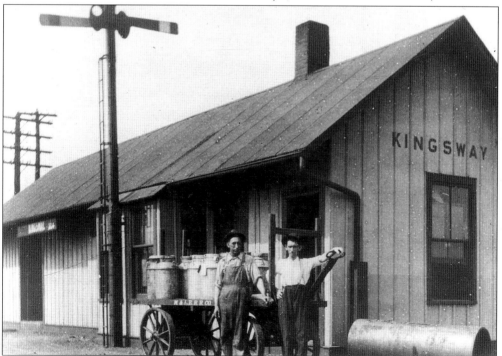

Kingsway was built to the same plan as Trowbridge, probably about 1882. The agency closed in 1950. The depot must have been torn down shortly after. (Bob Lorenz collection.)

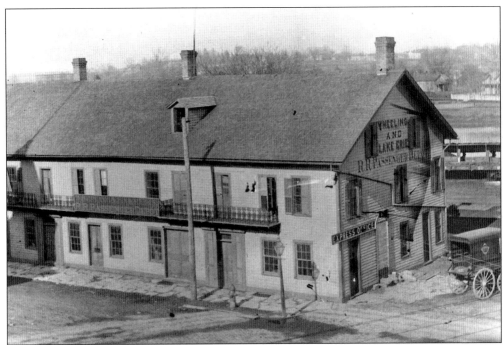

W&LE's original depot in Fremont was in the Kessler House, above. This building served from 1882 to 1897, when it was replaced by the brick passenger depot, below, and an adjacent freight house. Unfortunately, the W&LE's depot grounds were within the floodplain of the Sandusky River and subject to periodic inundation. The 1913 Flood wreaked havoc statewide. The Lake Shore Electric, an interurban line, also used the second W&LE depot. After 1938, the depot became a farm equipment dealership, but was torn down in the 1950s. (Above photograph from the Bob Lorenz collection; below photograph from the Mark J. Camp collection.)

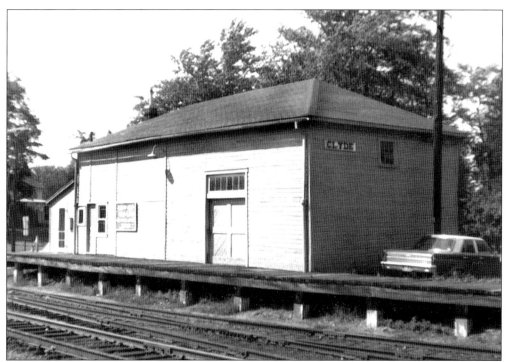

After passenger service ended in 1932, W&LE moved the Clyde agent to this freight house. This photograph dates to 1966; the building was gone by the 1970s.

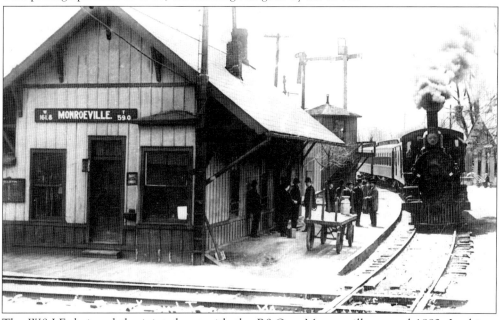

The W&LE designed the joint depot with the B&O at Monroeville around 1882. In this c. 1905 view, a W&LE passenger train is pulling in. Just behind the depot is a tower at the LS&MS crossing, and to the right of the locomotive is the LS&MS depot. The Nickel Plate closed their agency in 1956. The depot is now part of Coupling Reserve, an Erie County MetroPark near Milan. (Mark J. Camp collection.)

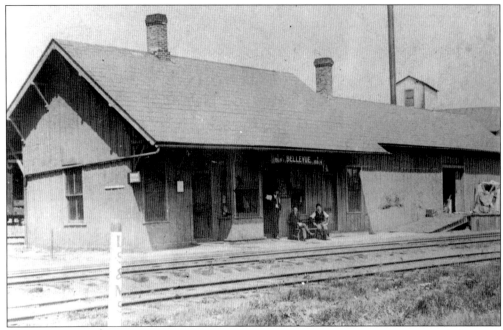

Bellevue's W&LE depot was built to the same plan as Curtice, but had an extended freight room. After the railroad closed the building, it became a feed store, but by the 1960s was vacant. Unfortunately, the depot was destroyed before the railroad museum began, or it may have been saved. (Mark J. Camp collection.)

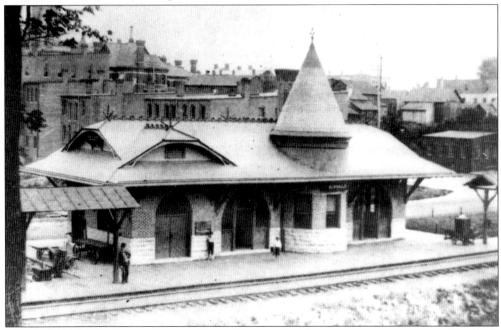

W&LE built this passenger depot in Norwalk in 1889. After passenger service ended in 1932, the building was converted to freight use. The conical tower was removed in the mid-1900s. The W&LE also had shop facilities in Norwalk in the early 1900s. Terminal facilities were at the junction with the Huron Branch. (Mark J. Camp collection.)

# Four

# OTHER LINES

## The Ann Arbor Railroad

The year 1871 marked the opening of the Toledo and State Line Railway, connecting the Detroit and Canada Southern tracks in Toledo with Alexis, a station near the Michigan state line. This five-mile stretch became the Ohio portion of the Ann Arbor Railroad in 1895, during a reorganization of the many predecessor lines that eventually connected Toledo with Frankfort, Michigan, on Lake Michigan. After periods of control by the Wabash and DT&I and operation by Conrail and Michigan Interstate, in 1988 a new Ann Arbor Railroad formed to operate the Toledo to Ann Arbor stretch. Ann Arbor depots were built to a series of standards, but with the exception of Toledo and Alexis, they were all located in Michigan.

The Ann Arbor Railroad had its southern terminus at this stub-end passenger depot on Cherry Street in Toledo just west of the W&LE depot. Behind it was a long freight house. The last Frankfort Firecracker steamed out of the depot in 1950. The wrecking ball came in the summer of 1964. (Mark J. Camp collection.)

# Detroit, Toledo and Ironton Railway

The DT&I formed in 1905 from the reorganization of the Detroit Southern, organized in 1901 from the consolidation of the Detroit and Lima Northern and Ohio Southern Railroads. The D&LN originated as the Lima Northern Railway in 1895, chartered to build a line to connect with the Ohio Southern Railroad at Lima and extend into Michigan. The D&LN completed its line through northwest Ohio in 1898 and built a series of standard-plan depots. Between 1925 and 1929, under Henry Ford's ownership, the DT&I constructed the 55-mile Malinta cutoff, abandoning an earlier route through Denson, Oak Shade, Ottokee, Wauseon, Naomi, Gerald, and Napoleon in favor of a straight shoot from Petersburg, Michigan, to Malinta. The cutoff did not pass through any communities, so standard depots were not needed. The old "ragweed branch" from Toledo to Dundee, Michigan, began when the Toledo, Ann Arbor and Jackson Railroad laid track in 1906 from West Toledo to near Petersburg, Michigan. It became the Toledo-Detroit Railroad in 1915 only to be leased by the DT&I in 1916 for its Toledo connection. DT&I removed the track in 1965 and entered Toledo by trackage rights. The year 1984 marked the end of the DT&I when it became part of the Grand Trunk Western. In 1997, the Indiana and Ohio Railroad took control. Only the offsite Denson depot of D&LN origin remains in northwest Ohio.

The DT&I's Denson depot, built c. 1898, was moved to a farm after its retirement by the rail line and modified for storage use. This view dates to 1991.

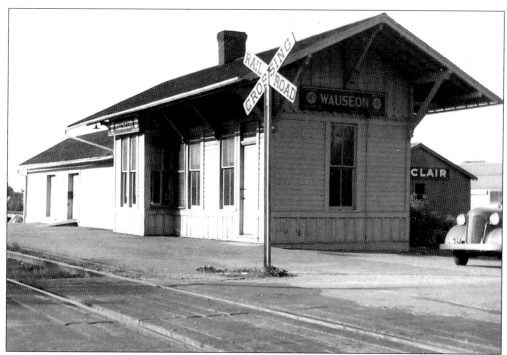

Wauseon had a standard plan Detroit and Lima Northern combination depot dating to 1898. A freight addition was added at some point on the north end. In later years, it was used for storage. The depot was torn down in 1976. (1946 Gustave Erhardt photograph.)

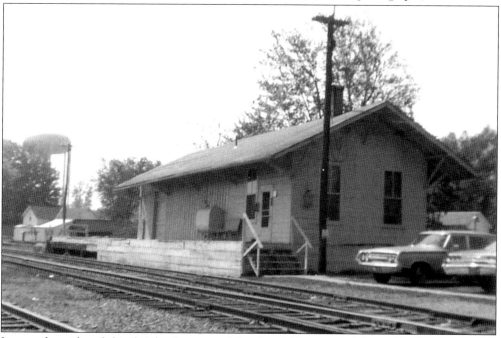

Just to the right of this freight depot was Napoleon's Detroit and Lima Northern passenger depot, a little longer but identical to the Wauseon structure. The freight station, shown here in 1967, is now preserved on the Henry County Fairgrounds.

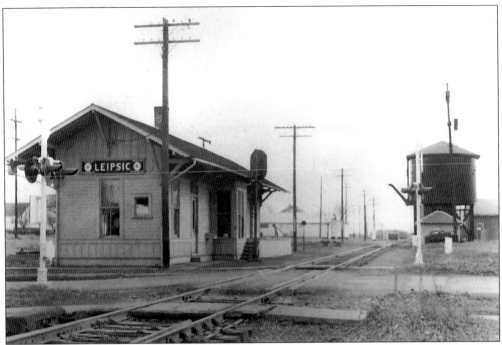

Leipsic also had an 1898 D&LN depot, shown here in the 1950s. Around 1966, this depot was replaced by a metal prefab, which still stands. Just north of here, the DT&I crossed the NYC&StL where brick KN Tower operated from 1931 to 1981. (David Longsworth photograph, Allen County (Ohio) Historical Society.)

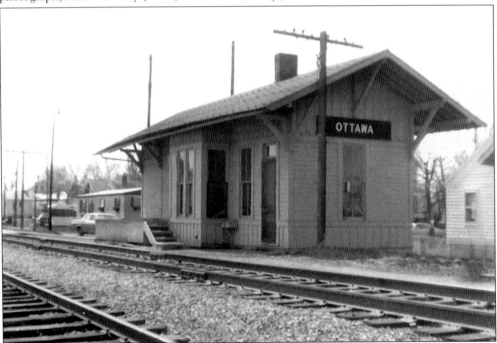

Another near identical D&LN depot, photographed in 1967, was at Ottawa, . The Lima Northern reached here in December 1895. This 1898 depot was torn down in 1972.

# The Hocking Valley Railway

The Hocking Valley Railway, which stretches from Walbridge to Gallipolis, originated in 1864 with the chartering of the Mineral Railroad, later Columbus and Hocking Valley Railroad, to connect Columbus with the rich coalfields of southeastern Ohio. In 1877, the Columbus and Toledo Railroad, a continuation of the C&HV northward, opened between the namesakes. The line had trackage rights from Walbridge into Toledo. The year 1881 marked the merger of this line with the Columbus and Hocking Valley to form the Columbus, Hocking Valley and Toledo Railway, familiarly known as the "Hocking Valley." The CHV&T fell under control of the C&O in 1910; currently it's CSXT. The CHV&T engineering office designed depot plans; one hipped roof design was repeated extensively. Unfortunately, in northwest Ohio, only the Fostoria freight station remains.

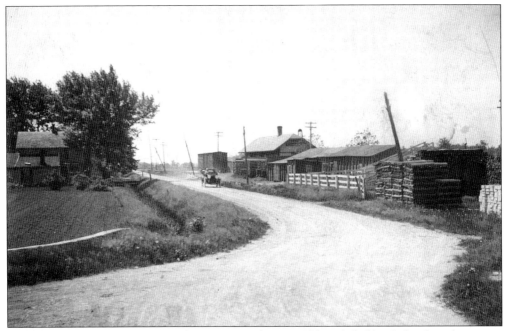

The CHV&T depot at Lemoyne dates to around 1877. Although hidden behind cattle pens, it follows a standard plan repeated from station to station along the Hocking Valley. Lemoyne closed in 1968 and was torn down in the late 1970s. (Victor Hahn photograph, Mark J. Camp collection.)

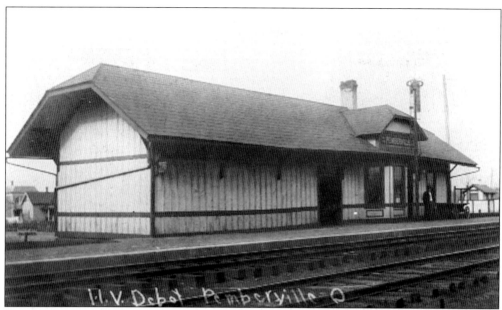

The freight room of Pemberville's depot was considerably longer than at Lemoyne. The half-hipped roof and gable over the bay window was characteristic. The depot closed in 1968 and was dismantled in the 1970s. (Mark J. Camp collection.)

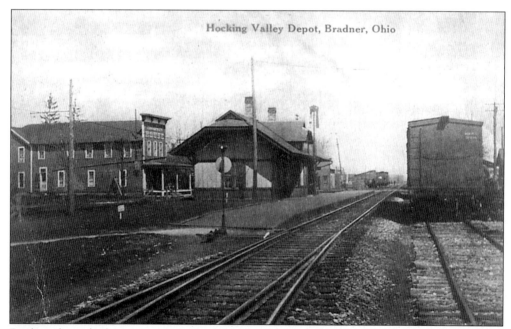

Bradner depot had a variation in the hipped roof, but otherwise fit the standard plan. The Thompson House, the local hotel, served as the depot for the Toledo, Fostoria and Findlay interurban. Bradner's C&O agency closed in 1966, and the depot was removed the next year. (Mark J. Camp collection.)

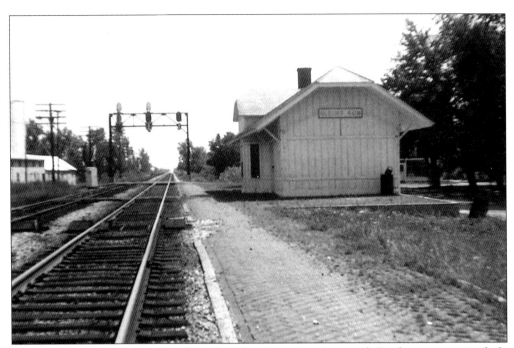

The depot in Risingsun was another of similar design. It, along with Bradner, was particularly busy during the oil boom of the early 1900s. The agency also closed in 1966, and the depot was torn down in 1967. (1964 Charles Garvin photograph.)

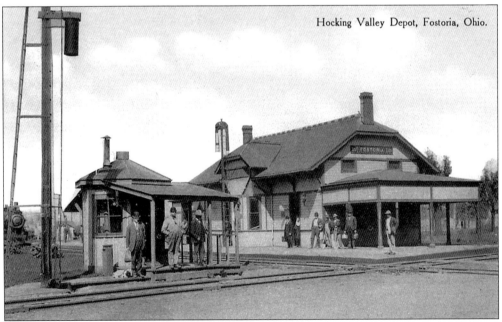

Hocking Valley Depot, Fostoria, Ohio.

The CHV&T depot in Fostoria was located at the Lake Erie and Western crossing. The small building across from the depot sheltered the signal operator. A small freight depot (still standing) was built adjacent to the depot. The depot was demolished in the 1970s. (Mark J. Camp collection.)

# The Lakeside and Marblehead Railroad

The stone quarrying industry of the Marblehead Peninsula led to the opening of the Lakeside and Marblehead Railroad in January 1887. The shortline connected to the LS&MS just north of the original Danbury depot and served Violet, Piccolo, Lakeside, and Marblehead. Stone shipment and resort business dominated the early days of the L&M. The line closed in July 1964.

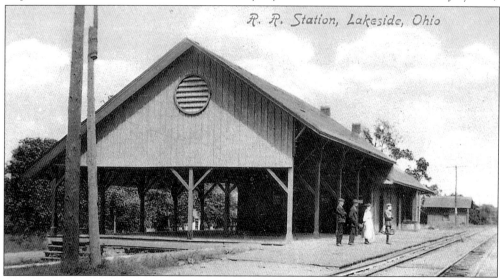

This is the second depot to be built at Lakeside. The original, much smaller depot opened in 1886, but was soon moved down the line to Picolo. The new depot had a large open air covered waiting area on the west side of the building to help with the summer crowds. In later years, this was enclosed. Passenger service ended in 1930. The depot became a printing company when the L&M ceased operations in 1964. In 1995, the depot underwent restoration to its original appearance. (Mark J. Camp collection.)

The Marblehead depot was built in 1886 and became the center of operations for the L&M. Nearby was a two stall stone engine house that stood until 1992. The depot was removed c. 2001. (1965 Charles Garvin photograph.)

# The Pennsylvania Railroad

In 1873, the Mansfield, Coldwater and Lake Michigan, under Pennsylvania Railroad control, opened a line between Toledo Junction, a few miles west of Mansfield on the Pittsburg, Ft. Wayne and Chicago mainline, to Tiffin. Although track was laid from Tiffin to Weston, this trackage came up around 1874 even though the original intent was to build to around Allegan, Michigan. The year 1873 also marked the opening of the Toledo, Tiffin and Eastern Rail Road, another PRR offspring, connecting Tiffin to Woodville and the Toledo and Woodville Railroad, stretching between the two namesakes. These PRR affiliated lines became part of the Northwestern Ohio Railway between 1876–1878. The Pennsylvania Railroad formally leased the line in 1879. In 1902, the Pennsylvania also took over the former Columbus, Sandusky and Hocking Railroad (opened in 1895) between Sandusky and Columbus. The more southerly part of the CS&H became New York Central property. In 1967, the PRR became part of Penn Central and in 1983, part of Conrail. Today, CSXT operates the line; no depots remain.

The Pennsylvania Railroad erected this passenger depot and a neighboring freight house along Summit Street in Toledo in 1879. This 1960 photograph shows the Red Arrow just in from Detroit. This building was demolished in January 1967. The freight house lasted longer, until a spectacular fire led to its demise in March 1998. (Bob Lorenz photograph.)

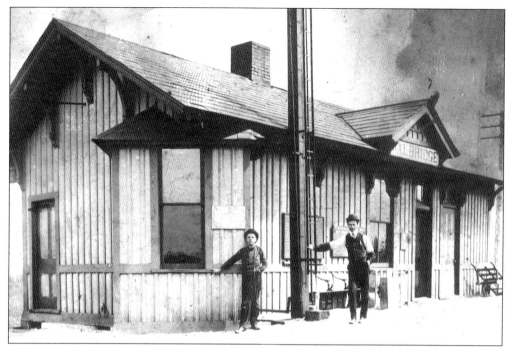

Walbridge, although better known as a Hocking Valley and later C&O terminal, was served by this Pennsylvania RR depot until the 1920s. It probably dates to the 1870s. The only PRR structure remaining in recent years is Walbridge tower. (Kirk Hise collection.)

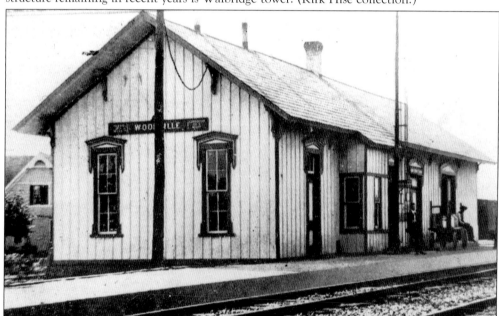

Woodville's depot was of Toledo, Tiffin and Eastern design, probably built around 1872. In later years, the PRR added shingle siding, removed trim, modified the bay window, and changed the arrangement of doors and windows. Woodville was kept busy by the many nearby stone quarries, even after the passenger agency closed in 1951. The depot on North Walnut Street, however, was torn down after an October 1995 fire. (Mark J. Camp collection.)

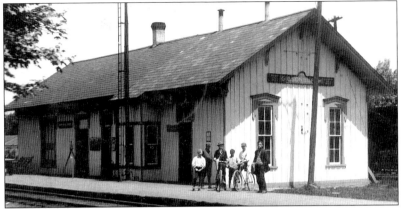

The Gibsonburg depot was built in 1872 to the same plan as Woodville, but the contractors switched the position of the waiting and freight rooms. Compare these two views taken in 1910

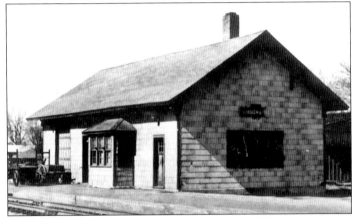

and 1950. Gibsonburg was another quarrying center, so the freight business was good. The passenger agency was removed in 1953. The building was removed in October 1989. (Mark J. Camp collection.)

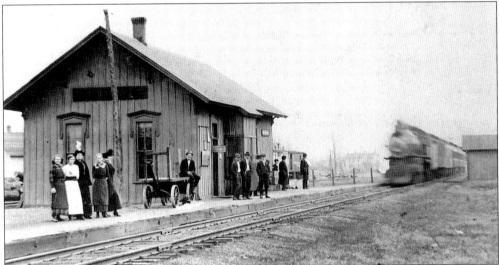

Another identical TT&E combination depot served Helena. The local passenger is about to arrive in this 1905 view. The depot closed in 1962 and has since been removed. (Mark J. Camp collection.)

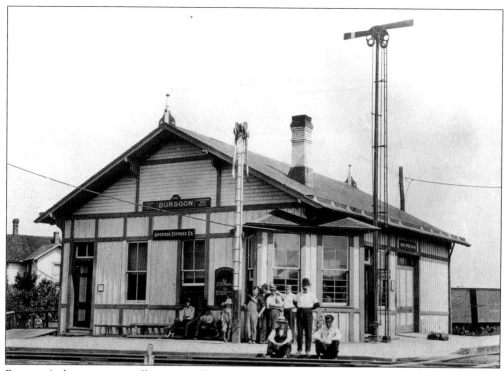

Burgoon's depot, a joint affair originally serving the Lima and Fremont and Toledo, Tiffin and Eastern railroads, reportedly dates to around 1867. In the early days, the depot was the place to be in this small Sandusky County community. The depot was removed in 1932. Burgoon Tower guarded the crossing until its closing in 1962 and removal in the summer of 1971. (Bob Lorenz collection.)

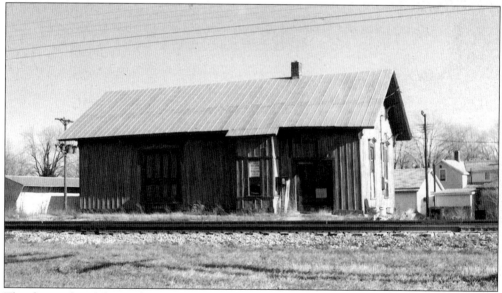

The depot plan did not change at Bettsville. The passenger agency closed in 1953, and the depot was boarded up after its closing in 1962. It has since been torn down. (1965 Charles Garvin photograph.)

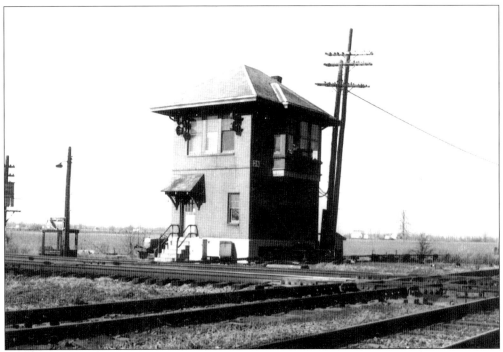

Maple Grove's PRR DN Tower dates to the 1930s and operated until the spring of 1979, long after the union depot was removed. (1965 Charles Garvin photograph.)

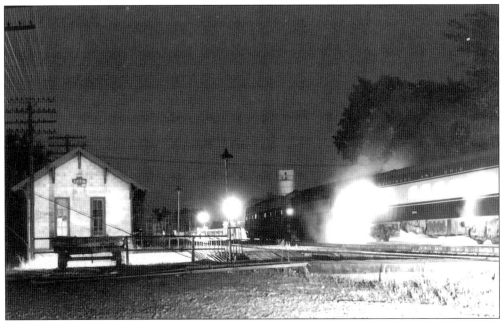

Tiffin's 1872–73 TT&E depot sat across the tracks from the B&O depot. Again, it followed the same plan as the other depots on the line. This 1960 photograph shows the modified version of this depot. A B&O passenger train is stopped at the B&O depot across the tracks. Only a vacant PRR freight house remained by 1967. (Bob Lorenz photograph.)

At the throat to the PRR's Sandusky yard was Bayside Tower. The single-story building was of PRR design and was either constructed on site around 1902 or moved in from another site on the Pennsy System. By this 1967 view, it was no longer in use. It has since been removed.

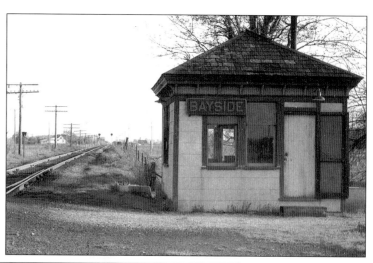

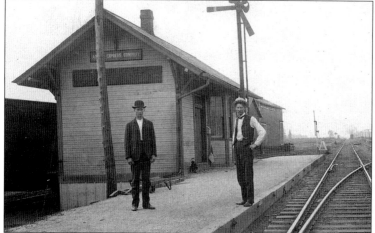

This depot at Franks was probably of Columbus, Sandusky and Hocking Railroad origin. It dates to 1892–1893. It has been gone for some time. (Mark J. Camp collection.)

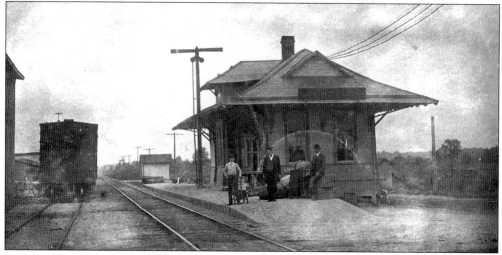

Attica's depot also reportedly dates to 1892–93, another design of the CS&H. The depot was gone by the 1970s. (Mark J. Camp collection.)

# Toledo Railway and Terminal Company

In a plan devised to tie together the lines radiating out of Toledo—the Toledo Railway and Terminal Company opened a belt line around the city in 1903 including a large passenger terminal on Cherry Street. Plans were for the CH&D and Pere Marquette to share the facility, but after four years, it greeted its last passenger train, serving its remaining years as offices and an exhibit hall. Chessie System, today CSXT, took control of the Toledo Terminal in 1983.

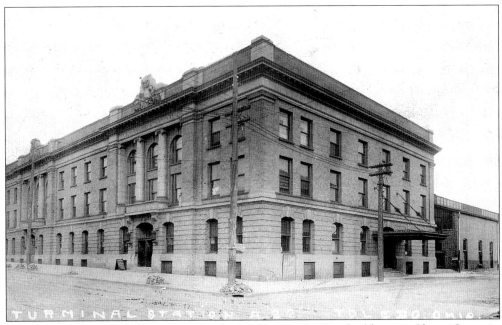

The Toledo Railway and Terminal Co. had a depot and office building on Cherry Street in Toledo just across Seneca Street from the Ann Arbor depot. The building dates to 1902, but passenger trains only used it until 1907 before being shifted to Union Station. By 1913, aside from a few railroad offices, the building reverted to commercial use. The train shed burned in 1927 and was consequently torn down. The Toledo Terminal closed their offices there in 1966. After sitting essentially vacant for some years, the main building was demolished in August 1971. (Mark J. Camp collection.)

# The Wabash Railway

The year 1853 marked the incorporation of the Toledo and Illinois Railroad to build a line through the Maumee River Valley from Toledo to the Indiana border and to connect with Indiana and Illinois lines to reach St. Louis. In 1855, the first train ran from Toledo to Fort Wayne; by 1856, the line reached the Indiana-Illinois border. After a couple of name changes, the line became the Toledo, Wabash and Western Railway in 1865 and then simply the Wabash Railroad in 1889. The Detroit, Butler and St. Louis Railroad, organized to build a line from Butler, Indiana, to Detroit, Michigan, opened in August 1881, bisecting Williams County. The Wabash then set its sights on Chicago, taking advantage of segments of the old Chicago and Canada Southern grade to build a line from Montpelier on the Detroit line to the windy city. The eastern part of the line opened between Montpelier and Wolcottville, Indiana, in late 1892; the rest opened in the spring of 1893. The year 1901 marked the conclusion of major Wabash construction in northwest Ohio with the completion of a direct connection between Toledo and Montpelier. The Wabash disappeared into the N&W system in 1964; what's left belongs to the Norfolk Southern and Indiana Northeastern Railroads. Depots from Antwerp, Defiance, Delta, Edon, Elmira, Jewell, and Liberty Center still stand.

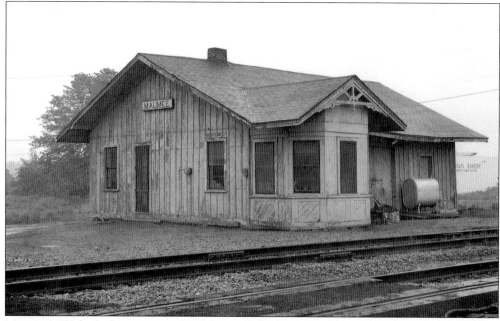

Maumee's Wabash depot reportedly dates to 1855. The depot appears to have been modified around 1900 by adding the bay window and gingerbread characteristic of Wabash depots built between 1890 and 1905. The building also appears to have been shortened by the removal of the passenger end. The N&W has since replaced the depot by a prefab building.

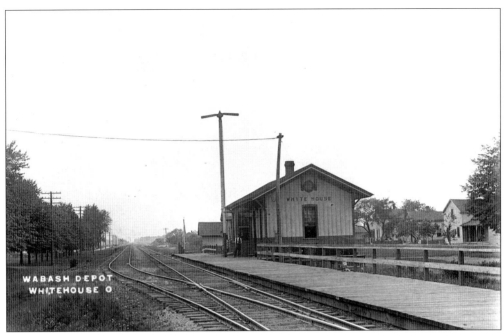

This is the third depot to have been built at Whitehouse. The first, a Toledo, Wabash and Western boxcar, was in 1864 when the town was platted. The second was probably built about 1867. It burned down, and the pictured depot was built, perhaps as late as 1879. The depot was dismantled in 1962 and reportedly stored for future reassembly. Unfortunately, know one remembers the storage site. (Mark J. Camp collection.)

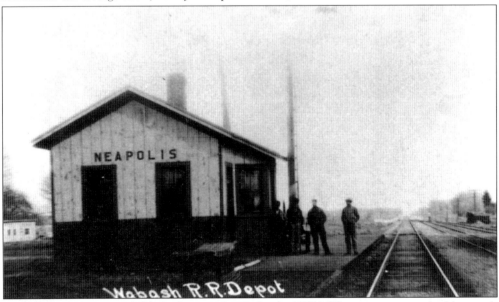

Neapolis' first depot, probably built around 1874 by the TW&W, was a two-story building with living quarters for the agent. This building was moved elsewhere in town for residential use and replaced by the above smaller depot. Instead of a separate town board, the name of the station was stenciled directly on the building. A 1928 disagreement over the name of the station left the depot nameless and only referred to as Station 15 by the Wabash. (Mark J. Camp collection.)

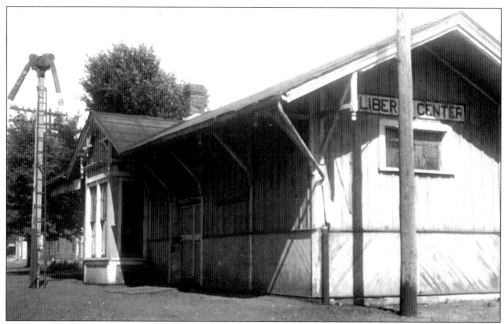

This Liberty Center depot dates to around 1891 and was a replacement to an earlier structure built by the TW&W in the 1860s. The earlier depot, as in Neapolis, was converted to a house in town. The last passenger train to stop was in 1959. The depot closed in 1965 and was relocated off the right of way in 1984. It now houses a museum. (1938 Gustave Erhardt photograph.)

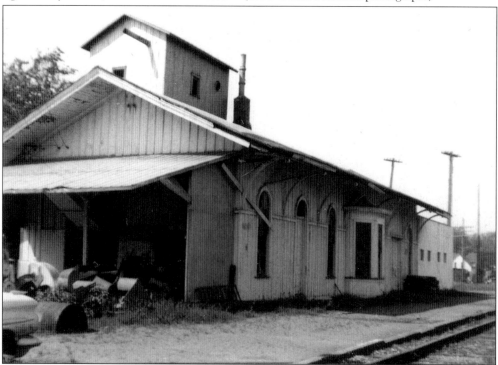

The Wabash passenger depot in Napoleon had been converted to other uses by the time of this 1967 photograph. The building probably dates to TW&W days. It has since been torn down.

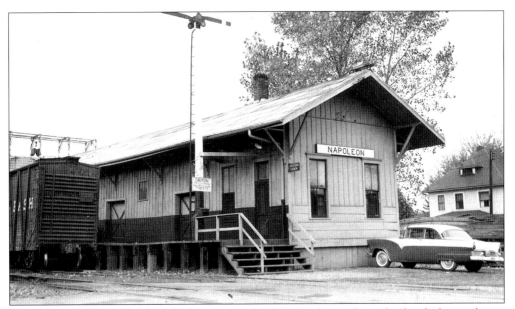

When the passenger depot closed, the agent moved across the tracks to the freight house shown here in 1955. The building was in poor shape by the 1960s and was removed by the 1970s. (Merle Graves photograph.)

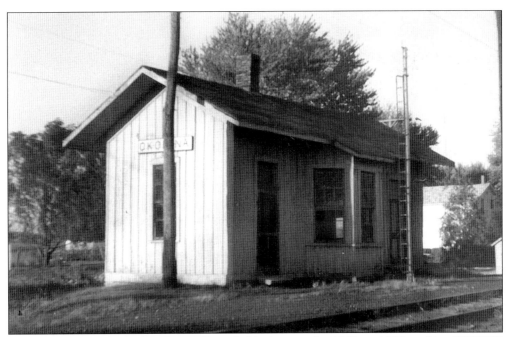

Okolona's depot, which closed in 1965, probably dates to the 1860s or 1870s and is of TW&W ancestry. It was built to the same plan as Neapolis, Jewell, and Knoxdale, but disappeared before 1970. (1964 Charles Garvin photograph.)

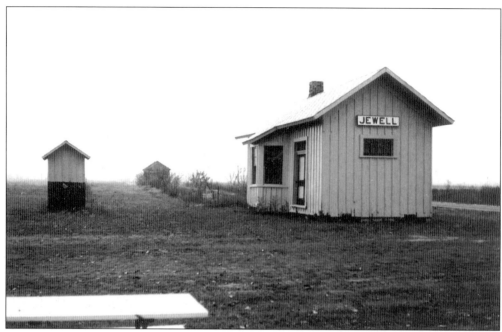

The TW&W depot at Jewell was moved in the 1960s to the grounds of Auglaize Village near Defiance and restored. Luckily, it was not destroyed in a 1957 tornado, which passed through the area. (1967 Charles Garvin photograph.)

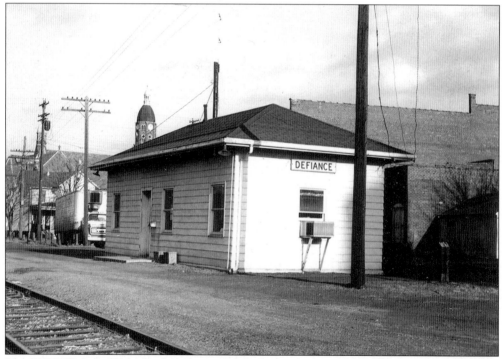

The TW&W, later Wabash, shared an 1875 Defiance depot with the B&O in the early days. This small building, still standing, is what remains of a much larger 1890 vintage Wabash passenger depot. (1965 Charles Garvin photograph.)

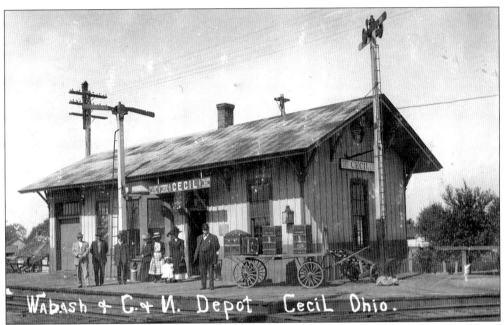

Cecil's TW&W depot became a union station when the Cincinnati Northern crossed in 1886. The depot was built to the same plan as Whitehouse and probably dates to the 1860s–70s. The CN town board to the right lists Cincinnati and Jackson as ultimate destinations, while the Wabash board announces St. Louis, Hannibal, and Toledo. (Mark J. Camp collection.)

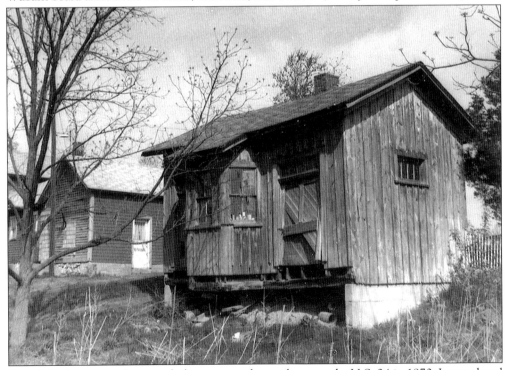

Knoxdale depot served as a work shop at a residence along nearby U.S. 24 in 1970. It was closed in the mid-1900s. It has since been removed.

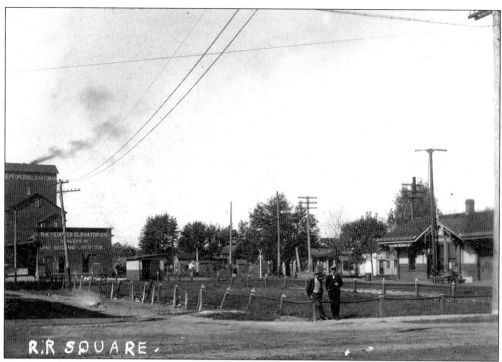

The western end of Antwerp's Wabash depot is seen in this 1907 view. The depot is of a style built by the Wabash in the 1890s and so is at least the second depot here. (Mark J. Camp collection.)

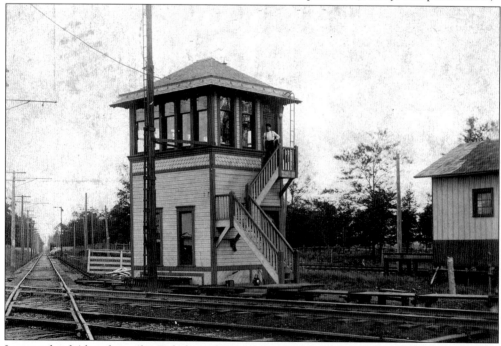

Just north of Alvordton, the Toledo and Western interurban crossed the Wabash at Franklin Junction. This interlocking tower, built in early 1904, and transfer freight depot have been gone since about 1940, when the electric line was abandoned. (Mark J. Camp collection.)

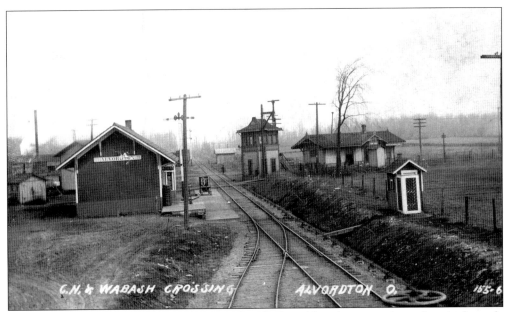

The junction of the Cincinnati Northern and Wabash in Alvordton was a busy place in the early 1900s. The CN depot is on the left and the Wabash depot and tower are in the background. Note the "one-holers." The Wabash depot may be the second depot at this location, as it is of a design used from the 1890s to around 1900. The depot closed in 1965. The tower was the last structure to be torn down, some time in the late 1980s. (Mark J. Camp collection.)

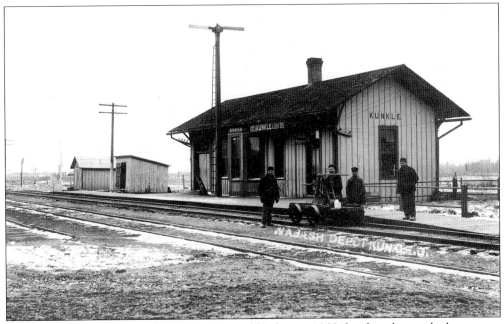

The depot at Kunkle opened in 1881. It's a cold February 1908 day, but the gandy dancers are out on the line. Kunkle's agency closed in 1959; the depot's been gone since the 1960s. (Mark J. Camp collection.)

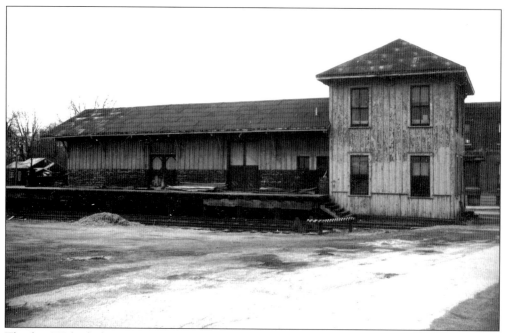

The first Wabash depot opened in Montpelier in July 1881. This depot was moved in 1895 and converted to a freight house, shown above, while a new depot (below) was erected. To feed the travelers and train men, the Ballard and Johnson Restaurant opened just east of the depot. Montpelier became the hub of the Wabash in northwest Ohio with the completion of east and west connections in 1901. The shops were moved here in 1908 and division offices in 1917. At first the offices were housed downtown, but moved to east of the depot in two new buildings, replacing the old restaurant in 1936. The last passengers left Montpelier in 1971. Railroading was slowly dying in town, symbolized by the destruction of the depot in 1982. Tracks from Maumee to Montpelier were abandoned in 1991. (Above, 1967 Charles Garvin photograph; below, Mark J. Camp collection.)

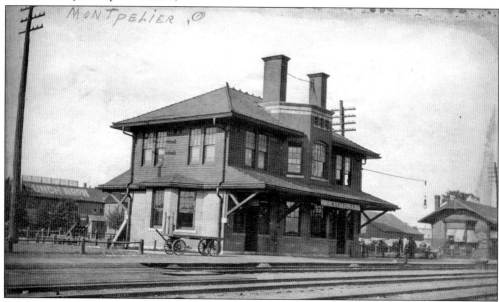

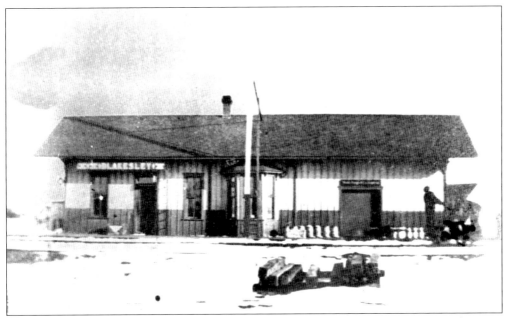

The Blakesley depot opened in 1881. This view, taken around 1910, catches it in between trains. It was gone by the 1960s. (Mark J. Camp collection.)

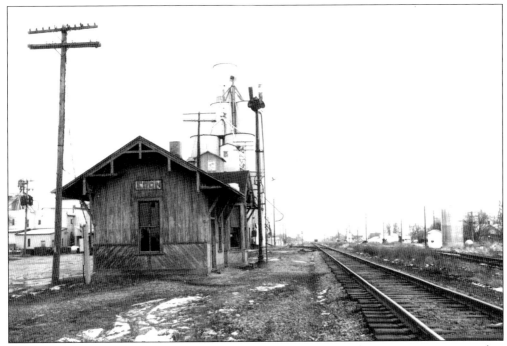

Edon's depot is similar to the depots built between Montpelier and Maumee. It was erected in 1892–3 and operated as an agency until the late 1960s. It now sits in a park on the north side of town restored as a community building. (1967 Charles Garvin photograph.)

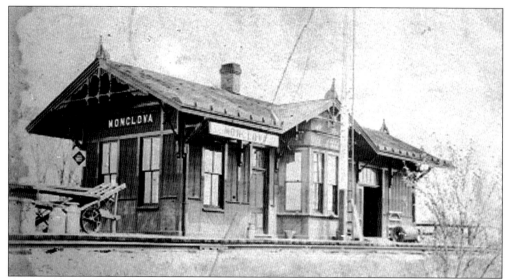

The Wabash's turn-of-the-century, small town depot architecture was perhaps the most attractive of all the lines in northwest Ohio. Monclova, which opened in 1901, is a good example. Note the gingerbread trim, finials, gabled bay windows, and patterned matte around the end town boards. The depot has been gone since the mid-1900s. (Mark J. Camp collection.)

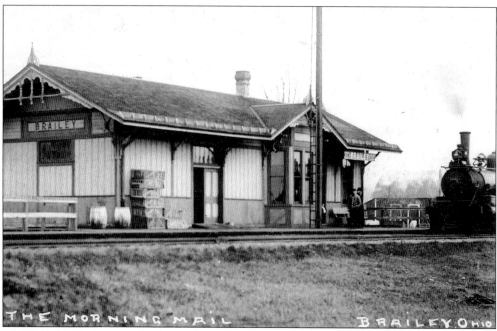

The depot at Brailey, nearly identical to Monclova, opened in 1901. The depot was relocated nearby after closing and is now restored. (Mark J. Camp collection.)

The Wabash passed south of Delta, so a separate small community—South Delta—sprang up around the depot. The depot opened in 1901 and is nearly identical to Brailey. It was moved to a farm, where it remains today. (1966 Charles Garvin photograph.)

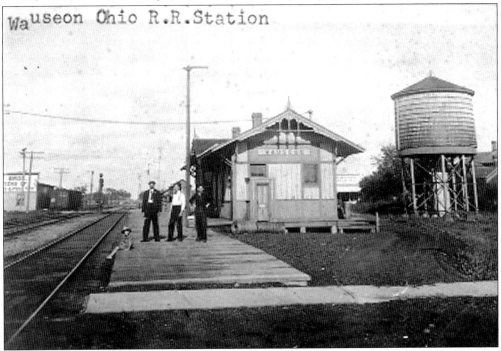

Another example of the 1900 Wabash style was at Wauseon. This 1966 view shows some modifications on the passenger end and the removal of the freight room. The depot was torn down in the 1970s. (Mark J. Camp collection.)

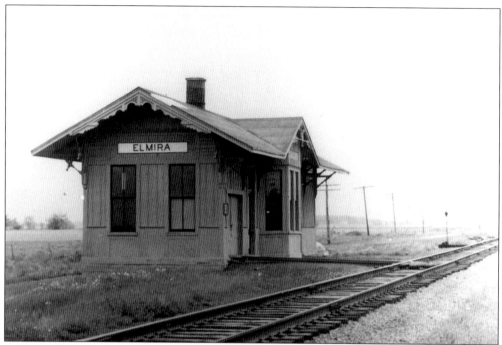

Elmira's 1901 depot appears desolate in this 1950s view. After closing in 1965, it was moved back from the track and used by a nearby elevator. It is now an important part of the historical village at Archbold's Sauder Village. (D. Longsworth photograph, Allen County (Ohio) Historical Society.)

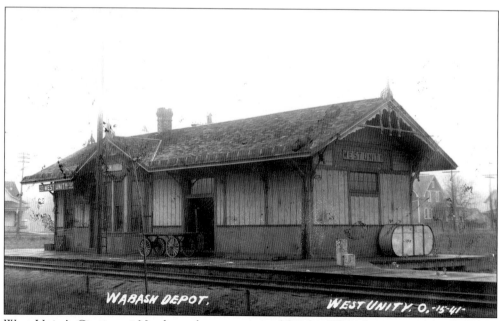

West Unity's Cincinnati Northern depot was joined by this Wabash structure in 1901. The depot closed in 1965 and has been gone since the late-1960s. (Mark J. Camp collection.)

# Five
# REUSE OF DEPOTS

Around 50 passenger and combination railroad depots remain standing in this part of Ohio; obviously many have disappeared. After closure by the railroad, depots become an unnecessary tax burden and are usually sold, moved, or demolished. Relocation of depots by new owners is common since most are small structures and easily moved and would remain a liability issue if left along an active rail line.

Structures at Delta, Deshler, Fostoria, North Baltimore, North Findlay, Oak Harbor, Ottowa, Sandusky, and Toledo still serve the railroads in some way. Amtrak uses portions of restored depots at Sandusky and Toledo and stops at one of the newest passenger depots in northwest Ohio—the small shelter at Bryan, across the tracks from the former Lake Shore and Michigan Southern depot. Other former depots serve the maintenance forces of the operating railroads. A popular reuse of depots is as a local history museum. Early examples in this area are the relocation of the Wabash depots from Elmira and Jewell to Sauder Village near Archbold and Auglaize Village near Defiance, respectively, and the moving of W&LE's Curtice depot to the Bellevue Railroad Museum. The furthest move is certainly the relocation of Bowling Green's CH&D depot to Carillon Park in Dayton. The LS&MS depot at Wauseon became a rare on-site depot museum, next to an active rail line. The depot museum in Pemberville is on site, but the T&OC track that once served the community is long gone. Some preserved depots also contain meeting rooms for community use. Restored depots from Antwerp, Brailey, Edon, Elmore, Liberty Center, Malinta, Maumee, Payne, Sylvania, and Weston reflect their past history. Waterville's TStL&W depot continues to serve the Toledo, Lake Erie and Western, a tourist line running between Waterville and Grand Rapids. Hatton's T&OC depot, once an antique shop, awaits removal to Findlay and restoration.

Conversion of depots to business, club, or community use, either on site or relocated, is also common. The record for different uses and number of relocations is held by the Danbury depot. After railroad use, it was moved to a nearby farm lot; then to Fort Firelands east of Port Clinton for a museum-gift shop that never developed; and finally to Fremont where it is now home to shops. Depots from Bryan, Castalia, Elmira, Findlay, Fostoria, Fremont, Leipsic, Lime City, Monroeville, North Creek, Norwalk, Ottawa, Perrysburg, Pettisville, Stony Ridge, Sylvania, and Tiffin fall into this category. Sometimes the historical ambiance is lost during the conversion to business use. Additions have more or less hidden any depot resemblance of the T&OC depot from Lime City, originally a radio station, and Pettisville's LS&MS structure, surrounded by a grain operation. In some cases, depots have changed ownership a number of times, and in the case of Pemberville and Sylvania, have since been restored and converted to museum use. Depots also make nice houses; however, some lose their distinctive characteristics in remodeling. Examples include Amsden, Arcadia, Portage, Rocky Ridge, Sugar Ridge, and Wayne.

Antwerp's Wabash depot sits on a new foundation, with new wood, and a trackside deck in 1980. The depot is on the west side of town between the old line and U.S. 24.

Some depot reuses result in complete remodeling, including siding and additions like the former NYC&StL depot at Arcadia, now a local residence. (Charles Garvin photograph.)

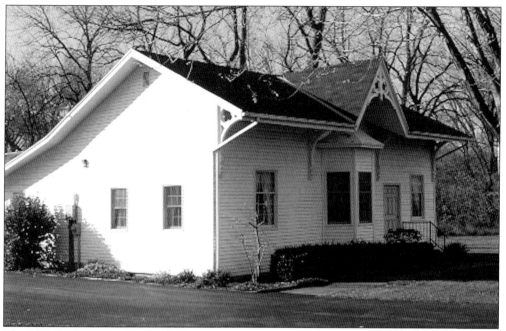

The LE&W depot at Castalia has received an addition, but retains the decorative gable over the bay window and the scrolled trackside roof supports. It serves as a community meeting hall on the north side of town.

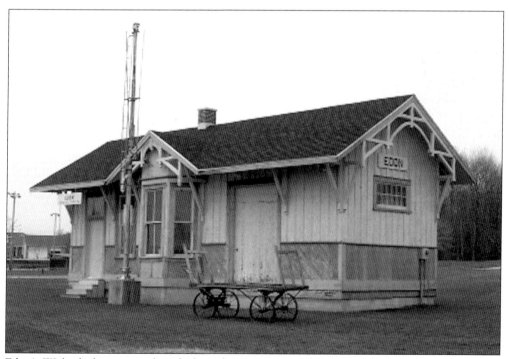

Edon's Wabash depot provides a link to the importance of the railroad in the town's past from its new location in the community park.

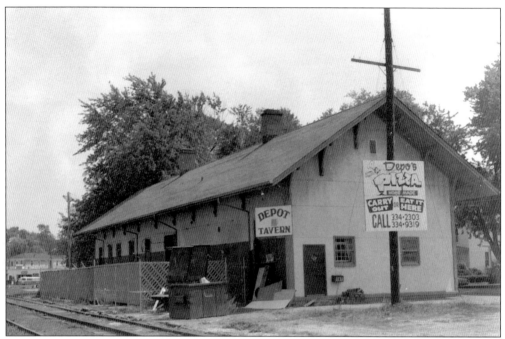

Restaurants and bars are a common use of retired depots. Fremont's LS&MS depot was one of the first such adaptations in northwest Ohio. In later years of railroad and Railway Express Agency use, the depot was covered with corrugated siding.

An early adaptation of the CH&D depot in Leipsic was as a church; note the added corner entrance. Later business use resulted in the garage door. Unfortunately, the siding hides most of the recognizable characteristics of the former depot.

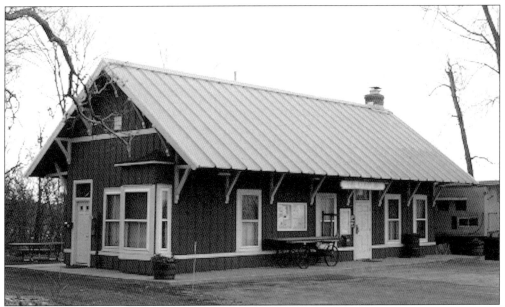

A Christian group did a nice job preserving the railroad motif of the W&LE–B&O depot from Monroeville after its move to near Milan. Cabooses were added to provide bunk space. The depot and cabooses are now part of an Erie County MetroPark and are available for rental.

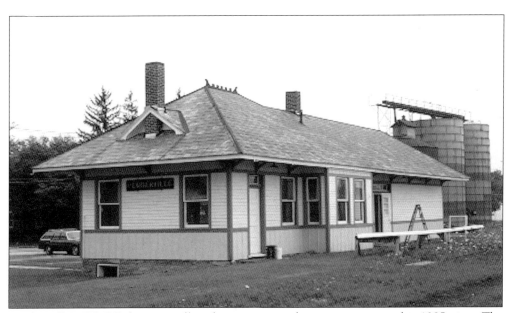

Pemberville's T&OC depot is still undergoing meticulous restoration in this 1985 view. The restored depot, turned history museum, continues to proudly serve the community. This is one of the nicer restorations in the state.

Depots have often been reused by nearby grain and feed companies for storage or office use. The LS&MS depot at Pettisville is hidden in the middle of this complex of buildings.

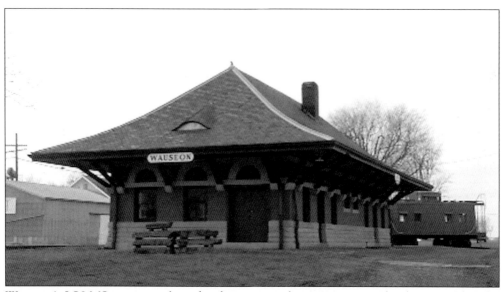

Wauseon's LS&MS passenger depot has been in nearly continuous use by the city. After the railroad left, it was used for city storage and in the 1970s converted to a fine history museum by the local historical society.

# INDEX OF PHOTOGRAPHS